CAPTURE THE PORTRAIT
HOW TO CREATE GREAT DIGITAL PHOTOS

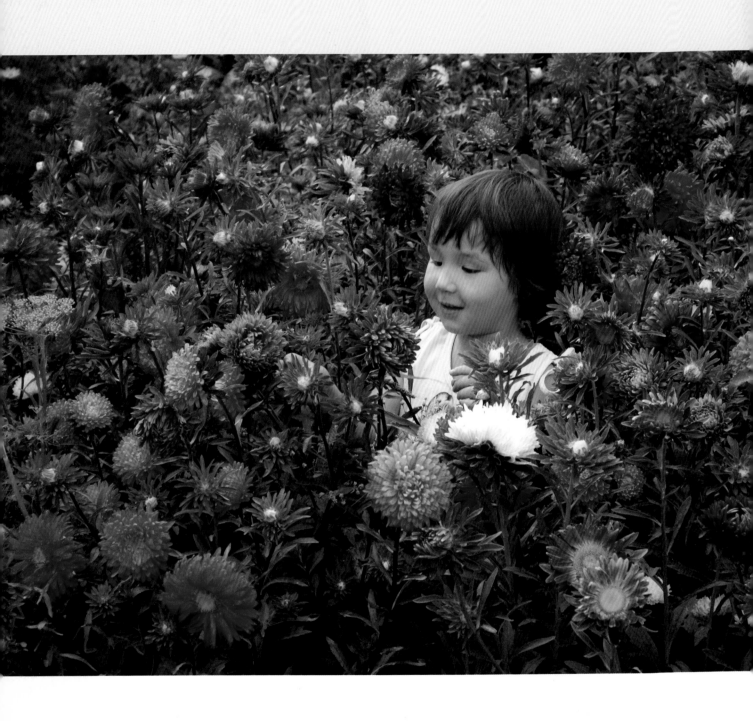

CAPTURE THE PORTRAIT

HOW TO CREATE GREAT DIGITAL PHOTOS

Jenni Bidner

Published by Lark Books

A Division of Sterling Publishing Co., Inc.

New York / London

Book Design and Layout: Tom Metcalf
Cover Design: Thom Gaines – Electron Graphics

Library of Congress Cataloging-in-Publication Data
Bidner, Jenni.
 Capture the portrait : how to create great digital photos / Jenni Bidner.
— 1st ed.
 p. cm.
 ISBN-13: 978-1-60059-269-0 (PB-trade pbk. : alk. paper)
 ISBN-10: 1-60059-269-4 (PB-trade pbk. : alk. paper)
 1. Portrait photography. 2. Photography–Digital techniques. I. Title.
 TR575.B4978 2008
 778.9'2–dc22

 2007041111

10 9 8 7 6 5 4 3 2 1

First Edition

Published by Lark Books, A Division of
Sterling Publishing Co., Inc.
387 Park Avenue South, New York, N.Y. 10016

Text © 2008, Eastman Kodak Company
Photography © 2008, Jenni Bidner on pages as follows:
5 (bottom), 17 (right), 36 (all), 54 (left), 56, 65 (bottom), 80 (top), 83 (left), 87 (bottom left), 93, 94 (top left), 94 (top right), 104 (all except middle right), 105 (left images), 111 (right images), 113 (bottom), 117 (left images), back cover (top left), back flap.
Photo page 104 (middle right) © Janet Anagnos.
Front cover top left © Robert Ganz
All other photos © istockphoto.com.

Distributed in Canada by Sterling Publishing,
c/o Canadian Manda Group, 165 Dufferin Street
Toronto, Ontario, Canada M6K 3H6

Distributed in the United Kingdom by GMC Distribution Services,
Castle Place, 166 High Street, Lewes, East Sussex, England BN7 1XU

Distributed in Australia by Capricorn Link (Australia) Pty Ltd.,
P.O. Box 704, Windsor, NSW 2756 Australia

Kodak and the Kodak trade dress are trademarks of Kodak used under license by Lark Books.

If you have questions or comments about this book, please contact:
Lark Books, 67 Broadway, Asheville, NC 28801
(828) 253-0467

Manufactured in China

ISBN 13: 978-1-60059-269-0
ISBN 10: 1-60059-269-4

For information about custom editions, special sales, premium and corporate purchases, please contact Sterling Special Sales Department at 800-805-5489 or specialsales@sterlingpub.com.

Kodak
Licensed Product

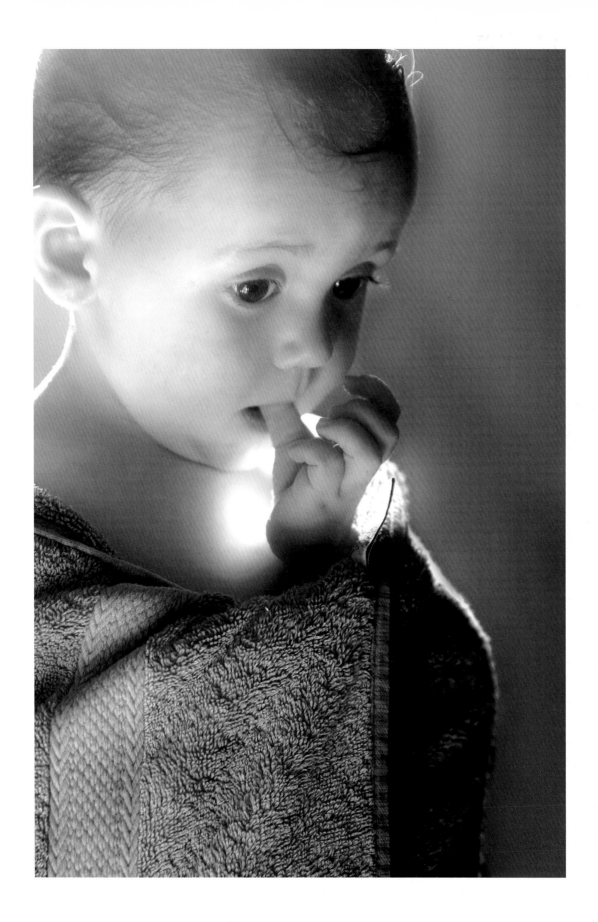

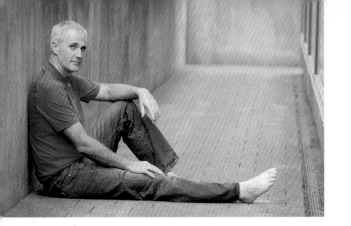

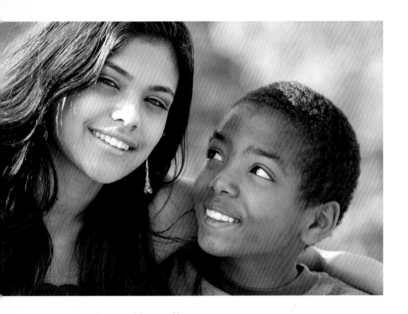

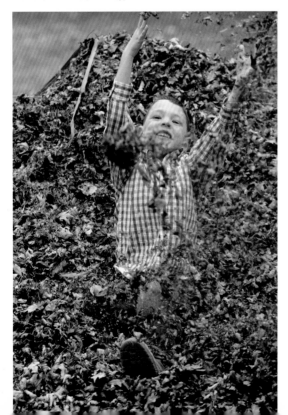

contents

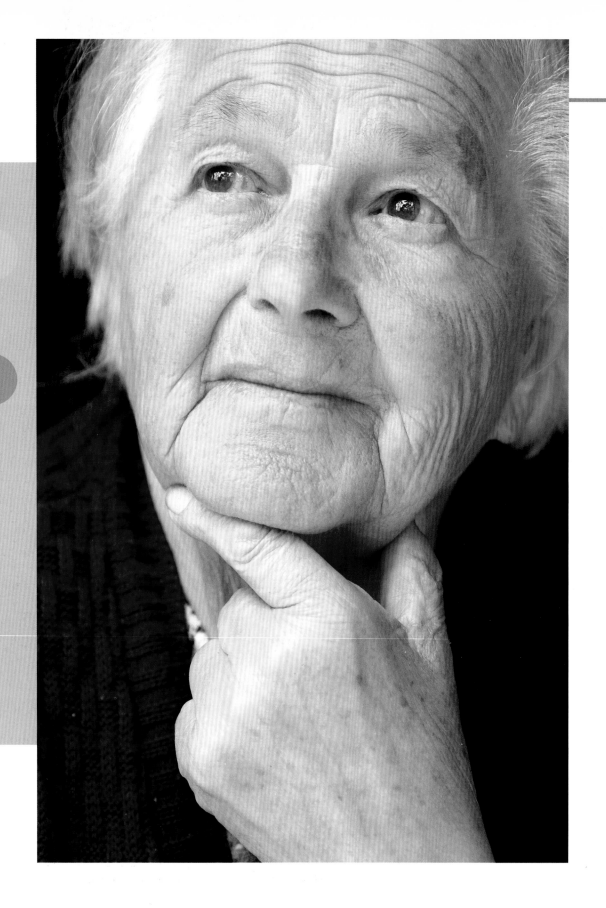

Introduction

What is a Portrait?

Before we jump into a discussion about how to photograph a portrait, I'd like to address an age-old question: "What is a portrait?" The answer to this question is well-known if we consider the classical portrait that painters have been doing for centuries, and photographers since the advent of photography.

This classic portrait has a person or a group of people in a stationary pose looking at the camera. Though a few daring artists and photographers in the past produced more moody portraits, in which the subject was looking away from the camera, often out a window or off into the distance, the basic structure has been defined and followed for a very long time.

Today, however, portraiture is much less limited! Modern cameras allow you to take pictures in almost any situation, including underwater (if you have specialized waterproof housing). Your subject can be moving or still, close or far away, and you can easily shoot from almost any angle.

A modern portrait, as I define it, is any image that tells you something about the person (or people) in the picture. And most modern portraits fall into the categories described on the following pages. When shooting portraits, don't limit yourself to just one or two categories! If you do, you'll be missing out on some of the most creative and rewarding aspects of portrait photography.

Classic portraits can still be made today, though they are most likely less formal than in the past. The classic style can be a full-body image or just a head-and-shoulders shot.

The Classic Portrait

When we think of the classic portrait, we think of the style described on the preceeding page, with the subject standing still and looking at the lens. The "standing still" part probably grew out of the technical needs of painters and photographers from long ago. It took days, if not weeks, to paint a portrait. And early photo processes took several seconds (and even minutes!) to make the exposure. Chairs and stands were made with clamps to help the subjects hold their pose for the duration of the exposure! And this explains why you'd often see antique images with blurred faces—especially with children and dogs, who were less likely to stay still for that long!

Slice of Life

One of my favorite types of portraiture bears little resemblance to the classic portrait. It is simply a photojournalistic picture that shows a moment in a person's life. If successful, it can communicate more about the person than a simple head-and-shoulders (sometimes called a headshot) photo. It often shows interaction between a person and their world, or people with each other. Slice-of-life pictures are usually candids. See Chapter 6 for more information on this type of photography.

"I Was Here!" Portraits

The mobility of today's cameras has allowed us to venture out of a studio and into the world for our portraits. Excellent light-sensitivity enables us to handhold the camera instead of being forced to carry a cumbersome tripod for all of our photos.

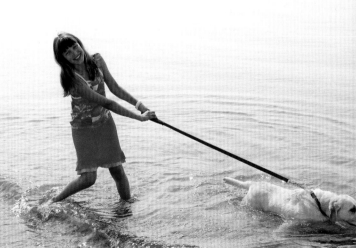

Slice-of-life pictures usually tell you more about the subject than a straight-on classic portrait.

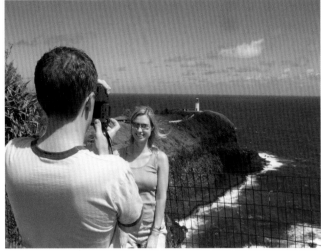

When this woman looks at this picture in the future, it will likely key many memories about her trip to the ocean and her visit to this lighthouse.

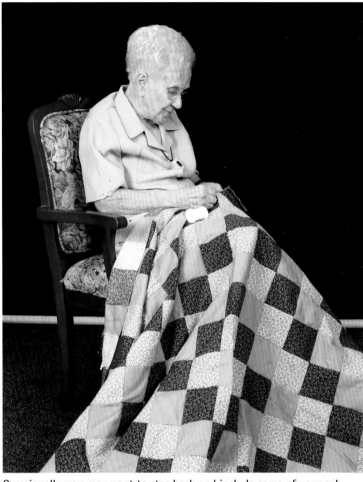

Occasionally, you may want to step back and include some of your subject's environment or activities. This can give the viewer background information and a story line about the person in the portrait.

This allows what I like to call the "I Was Here!" portrait. It is a picture where the person and the background are both important. It can be a vacation image in which a scenic vista or important monument is clearly visible behind the person. This kind of portrait is so much nicer than a photograph of just the scene, because you or your travel companions are included in the picture. And with easy-to-use services like www.kodakgallery.com, you can turn this photo into a postcard or greeting card. Or you can simply email it to your friends and family, and even upload it to your online travel blog if you have one.

Environmental Portraits

An environmental portrait is a variation of the "I Was Here!" vacation portrait. In this, you show the person's home or work environment, as a way to tell the viewer more about them. The picture then includes a lot of editorial content that tells a story visually. Think of the background as a way to include clues about the person's identity.

A very simple example is the quilting picture above. This environmental portrait shows Grandma working on an heirloom quilt. The antique chair she sits on reflects this traditional craft. Note how the photographer has fanned out the quilt in an attractive manner, so we can see Grandmother's handiwork in all its glory.

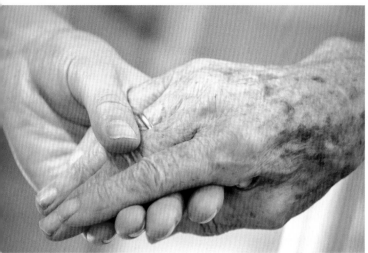
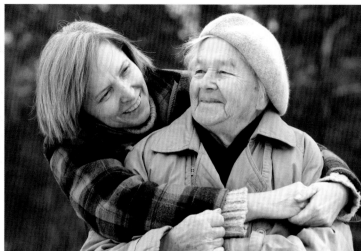

These two photographs together tell more about this mother and daughter than either single image can reveal. They can be framed together in a single frame, or printed as a two-photo collage.

Alternative Portraits

Another category is an unconventional approach that I call alternative portraiture. This is where the image might not include a person's face, or even a person at all! I've seen some very successful portraits that were still-life images of important things in the subject's life.

The holding hands photograph above tells us a lot about this mother and daughter—yet all we see are their hands! Is this a portrait? I think so. It could be nicely displayed in a double frame with a more classic portrait of the two. Together, these two pictures make a stronger portrait than either one alone.

Most people think a portrait must include the eyes. It can be great fun to experiment in other ways. Ask yourself how many different ways you can tell the story of a person without showing their eyes! If you try to shoot some of these variations, you'll probably come up with a rich group of images that will make your photo album come alive.

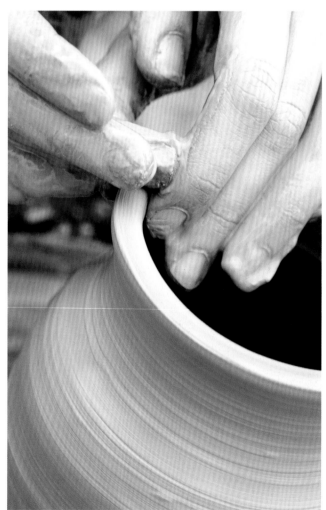

Is this picture of hands and clay a portrait of the pottery artisan? It certainly tells us quite a bit about the person in the picture, even though we cannot see her face.

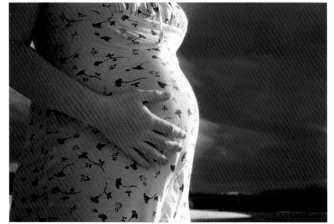

The light and subject in this alternative portrait of a mother and her unborn child creates a hopeful mood of possibilities for the future.

Other Types of Portraits

In future chapters, I will introduce other types of portraits and portraiture techniques, including action portraits, portraits with props, and low-light images. And let's not forget self-portraits. Many people tend to avoid these. But you should not. Even if you are not interested in seeing pictures of yourself, your loved ones will cherish them.

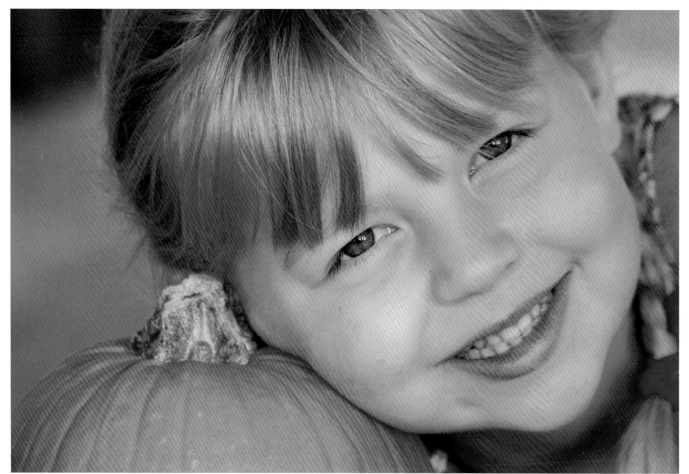

Seasonal props like pumpkins are a great way of marking the passage of time in a photo album.

Photo Fundamentals

1

If you're new to digital photography or just want to hone your skills, there are several camera functions and photo principles you'll need to learn to be successful at portrait photography. Don't worry— they're not hard! They're just important. But first, take a quick look at the different types of cameras available for your portrait work.

Point-and-Shoot or D-SLR Camera

Though manufacturers do make several different styles of digital cameras, including those with electronic viewfinders (EVF, sometimes called bridge cameras), there are two basic types: Compact point-and-shoot cameras and D-SLR cameras. For the most part, the point-and-shoot cameras are compact models popular with most people. D-SLR cameras are generally much larger and more expensive, and cater to the advanced amateur and professional photographer.

Both point-and-shoot and D-SLR cameras offer the ability to record great portraits. The point-and-shoot is more affordable and portable, while a D-SLR contains more advanced options.

But the lines are blurring. There are high-end point-and-shoot cameras that offer advanced features that mimic or are identical to those in D-SLRs. And there are D-SLR cameras that are so lightweight and easy to use, they are not dissimilar to a point-and-shoot camera.

Throughout this book, I will refer to camera functions that might not be available on all cameras. For example, the ability to control your aperture is handy in advanced portraiture (see pages 110-111), but this capability is limited to D-SLR cameras and some high-end point-and-shoot cameras. Check your instruction manual to see if your camera offers the various functions described in the book.

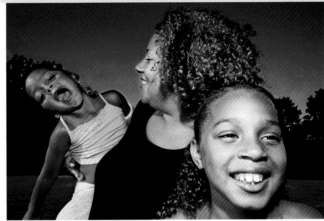

Spontaneous moments can be caught by being free with your camera and holding it at arm's length or crazy angles.

Holding the Camera

The most important factor when holding the camera is to keep it steady while taking a picture. Camera shake can cause blurry pictures, even if your camera has an image stabilization (IS) system. There is a technique for holding your camera firmly in order to minimize camera movement when you bring it up to use the viewfinder. Grasp the grip of your camera with your right hand, putting your index finger on the shutter release button. Use your left hand to cradle under the camera's body (or under the lens if it is large and long enough). Support both elbows by placing them down and in, against your torso. And finally, form a sturdy foundation by placing your feet apart, with one slightly in front of the other.

However, with digital cameras, you don't always have to raise the camera to your eye to look through the viewfinder. Most point-and-shoot types allow you to view the monitor to see what the lens is seeing. This is a big advantage, because you can avoid the problem of cut off heads or feet that so often occurred in the film days. Cameras that have foldout monitors give you a lot of versatility, because you can hold the camera over your head or down by your knees and still see the monitor.

I'm going to encourage you to have fun with your camera. Don't feel like you have to bring it up to your eye to shoot a picture—try shooting "from the hip" or at other crazy angles (but still hold the camera as steady as possible, though clearly you won't be able to cradle the camera and keep your elbows in). If your subject is shy or uncooperative (such as a small child or dog), then holding the camera away from your face (so they can see your face) is a good technique. We'll cover this more in other chapters.

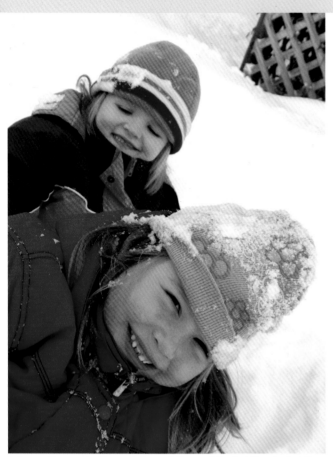

A fun action portrait was taken of these girls sledding by holding the camera vertically and at hip level.

Note: Most D-SLR cameras don't enable you to see a live picture on the monitor (although some are now offering that option), but you get a pretty close approximation in the viewfinder. You can also review your photo on the monitor after you take it.

An exception to holding your camera still occurs if your portraiture subject is moving. In that case, you'll want to smoothly pan the camera along with the moving subject.

To pan successfully, you actually move the camera to follow or track the progress of your subject, who is also moving. Don't stop panning suddenly—keep tracking for a moment or two even after you have pressed the shutter button.

Panning Technique

When your subject is moving, you'll get the best results if you pan, or move, the camera. To do this, follow the subject in the viewfinder or monitor before, during, and after you click the shutter button. This is called tracking. The more smoothly you do this, and the better your timing, the better your results. To pan smoothly, try to initiate movement from your hips rather than your arms.

Why does panning work? By keeping your subject centered in the viewfinder (and thus in the center of the digital imaging sensor), it is as if they are standing still in the camera. This will help you get sharper pictures of moving subjects—especially if they are moving across your field of vision (such as from left to right).

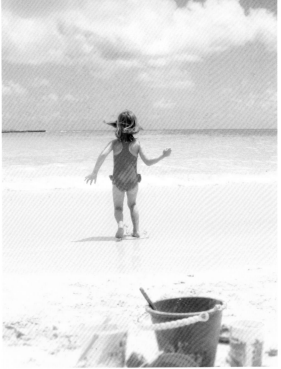

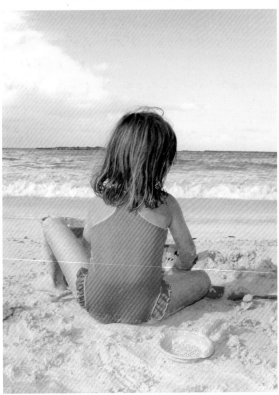

Shooting from a distance with a wide-angle lens shows more of the scene, and tells the story of a girl's first visit to the beach. Moving in close, and making the girl larger in the frame, creates a picture that tells more about her interest in building a sandcastle.

Zoom Settings

Most digital point-and-shoot cameras have a zoom lens that enables you to change the view in a range of increments from wide (W) to telephoto (T). The wide settings show more of the scene in front of you and make your subject look small in the viewfinder. The settings at the telephoto end of the zoom do the opposite. They zoom the lens so the subject is magnified in the picture, looking as though you are using binoculars.

For readers who have a D-SLR camera with interchangeable lenses, take note! You have a tremendous selection of wide, normal, and telephoto lenses to choose from, including some zoom lenses that include it all. The focal length, or focal length range, of the lens determines how wide or telephoto it is. Wide-angle lenses (and zoom range settings on a zoom lens) have focal length numbers that are low, such as 12mm or 18mm. Telephoto lenses have focal length numbers that are higher, such as 100mm or 200mm. The higher or lower the numbers, the more extreme the effect.

We will go into great detail on focal length selection for portraiture in Chapter 2. But suffice to say right now, it can make a huge difference in the look and feel of your resulting portraits.

Watch out for digital zoom settings. Some cameras offer optical zoom plus an "enhanced" digital zoom range beyond it. It is usually better to turn off the digital zoom and use only the optical zoom. This is because digital zooming degrades the image quality, whereas optical zooming does not.

When you shoot with a wide zoom setting from a close distance, you can get distortions. See Chapter 2 for more details.

Focusing Capability

Modern digital cameras have come a long way in terms of focusing capability. They rarely make mistakes on average pictures. And if they do, you can see it when you review the image on the monitor.

However, throughout this book I will be encouraging you to shoot pictures that go far beyond average. You will be taking pictures where the subject is off-center, or even moving. And these factors can affect the camera's ability to focus properly.

Check your instruction manual to see if your camera has center-oriented focusing or multi-segment autofocusing. The former will require you to use focus lock whenever your subject is off-center. The latter will give good results in most situations, but may occasionally require focus lock as well.

Using Focus Lock

Some cameras are designed to focus on whatever is in the center of the frame when you take the picture. This is great if your subject is centered, but in Chapter 3 I'll show how this is rarely the best composition!

If you find your off-center subject is blurry and the background or foreground is sharp, you'll need to initiate the function for focus lock. On most cameras, this is accomplished by:

1. Center the camera on the subject.

2. Push the shutter release button halfway down and hold it in this position to "lock" the focus.

3. Reposition the camera to the desired composition while still holding the button halfway down.

4. Push the shutter release the remaining distance to take the picture.

It sounds cumbersome. But after you practice it a few times, it becomes second nature.

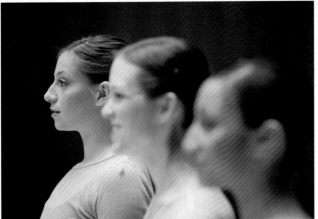

In the top photograph, the camera with center-oriented autofocus is pointed at the middle girl. In the lower photo, focus lock was used on the girl in the back, and the picture was recomposed before shooting.

Some cameras (mostly D-SLR cameras) offer a manual focusing option. This is a good choice for off-centered subjects or shooting beyond foreground objects that might fool the autofocus system.

You can often get wonderful portraiture results by coming in really close to your subject.

D-SLR cameras often allow manual focus control, which lets you focus on specific parts of the scene. Here, the active focus point or AF point is directed past the nearest chess pieces to focus on the eyes of the young player.

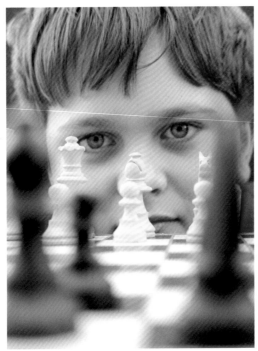

Close-Up Capability

Some of the techniques in this book encourage you to get close to your subjects. But watch out! You can sometimes get out-of-focus pictures if you are are closer than the lens can focus. On most point-and-shoot cameras, you can get within a foot or two in normal modes, and as close as a few inches in the Close-Up mode (usually indicated by a flower icon). With a D-SLR camera, it depends upon the lens you have attached to the body. Some may not focus closer than six feet, while others are designed for close-up (sometimes called macro) photography.

Shooting Modes

Some high-end cameras offer other shooting/exposure modes that weight the camera for certain types of subjects. AUTO Exposure and Program (P) are two modes found on most cameras. They will weight the camera controls for the average subject, and give you good results in most situations. The camera selects all photographic functions when set to AUTO (sometimes signified by a green rectangle or a green camera icon), while Program mode allows the photographer to control some of the settings.

If your camera has a Portrait mode, it is not surprising to learn that it can help improve portraiture pictures by putting the background relatively out of focus. It does not offer the kind of control you can get with the Aperture Priority mode on a D-SLR camera (see page 110), but it does weight the settings toward this effect.

Though unrelated to portrait photography, other exposure modes may be found on your camera as well. Most landscape photographers want their images to be sharp and in focus from foreground to background. Landscape mode helps by optimizing the camera toward this goal. For the portrait photograph, this mode can be useful if you want your subject and a distant background in focus, such as a scenic travel image.

Sport or Action mode sets the camera so that the shutter speed is as fast as possible for the given ISO setting (see page 23). Surprisingly, it sometimes sets the camera to exposures similar to Portrait mode. So if you don't have a Portrait mode and you do have a Sport or Action mode, try using it.

Your subjects don't need to be stationary for your picture to be a portrait. If there is enough light when the Action mode is selected, the camera increases shutter speed and/or ISO to freeze the subject's movement.

Macro, or Close-Up mode, optimizes the camera for shooting small subjects up close. If you are shooting an artistic portrait with just a portion of a person's face, you may want to switch to this mode if you are having difficulty with out-of-focus results using other modes.

Aperture Priority mode and Shutter Priority mode enable photographers to select the aperture (f/stop) or shutter speed, respectively. These advanced exposure modes offer more control over depth of field and subject motion, and are covered in more detail in Chapter 8.

Resolution

It is important to understand resolution. All digital pictures are made up of tiny pixels. The quantity of pixels in the picture determines the resolution of the picture. The more pixels you have, the more detail and clarity any given image will have.

High resolution is important. But how high is high? Most photographers will be very happy with the results they get with a camera that has a resolution range from four to six megapixels, even if they are making large prints. Advanced amateurs and professional photographers may want slightly higher.

Your camera probably has several choices for the resolution or picture size it can record. If you set it to the highest resolution with the highest quality, your results will be the best the camera can deliver. You can print it large, and the quality will be maximized. If you set it to a lower resolution or lower quality (more compressed) setting, you won't be able to enlarge the picture as much, and the quality may suffer.

The only advantage to shooting at a lower resolution and/or a more compressed setting is that you can record and save more pictures on any given memory card or memory stick. High-resolution pictures take up a lot more file space.

My advice is to always shoot at the highest resolution. You never know when that unimportant snapshot might turn into your all-time favorite. If you're worried about running out of memory before you have time to download the pictures to your computer and clear the card—well, buy a second card! They've become inexpensive compared to the prices of a few years ago, so it is a good idea to have a spare card or two.

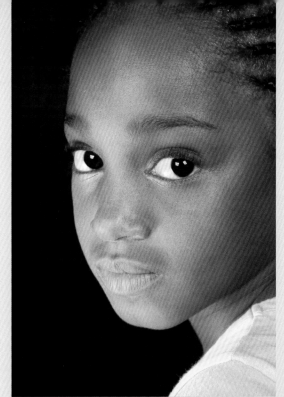

High-resolution pictures have more detail than low-resolution pictures, and can therefore be printed larger. The bottom picture looks fuzzy because the resolution is too low

File Format and Image Quality

There are several different existing formats for recording and saving image files. Digital cameras most commonly use JPEG and, with more advanced cameras, RAW. If your camera is able to record RAW files, it will apply little or no internal processing to them. You can then use software in your computer to read these files and make a wide range of adjustments to the unprocessed data. These are big files that contain at least 12-bit color information and a wide range of data.

JPEG is a standard for compression technology that yields smaller image files than RAW with 8-bit color information. You can usually select a degree of compression, or quality level, that may be found with various names depending on your brand of digital camera. These settings might be labeled something like Fine, Normal, Basic; or Best, Better, Good. The more compression applied to a JPEG file, the smaller it will be (and the less space it will take on your memory card), but the lower its quality.

Use an ISO setting that is as low as possible for the existing lighting conditions. Here, a car's headlights provide enough light for a setting of ISO 100.

Digital cameras can do a great job in low-light. Switch to ISO 800 or 1600 in these situations.

As the light gets lower, it becomes harder for your camera to deliver action-stopping shutter speeds. It also limits the camera's ability to keep everything in acceptably sharp focus from foreground to background, due to a phenomenon called depth-of-field that is affected by the lens aperture. Shutter speeds and apertures are discussed in more detail in Chapter 8. The chart below will help you select the right ISO Setting for a given situation.

Equivalent ISO

You may have converted from film to digital, but the concept of "film speed" hasn't disappeared. It is now known as Equivalent ISO (generally referred to simply as ISO), and it lets us rate the comparative low-light capabilities of digital cameras to the film speeds of days gone by.

The important thing to remember is that the higher ISO settings, like 800 or 1600, give you the best low-light capabilities. And like film, there is a corresponding drop in quality at higher ISO settings in terms of noise, contrast, and color.

Picture Results	Equivalent ISO Settings
For most outdoor portraits	Use auto ISO settings
If you are getting blurry pictures	Switch to a higher ISO setting or add flash (see chapter 5)
You want more of the background or foreground in focus	Switch to a higher ISO setting or to Landscape mode
You want less of the background in focus (create a pleasing blur in background)	Switch to lower ISO setting or to Portrait mode
Pictures too dark	Switch to a higher ISO setting, or turn on your flash (see Chapter 5), or use plus exposure compensation (see pages 112-113)

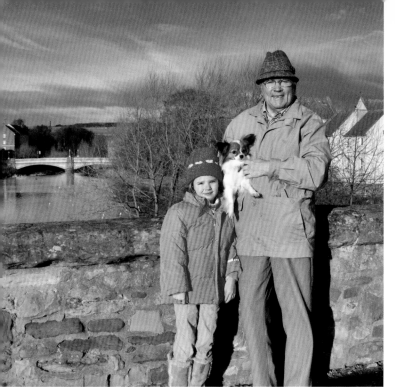

Late afternoon sunlight tends to be warmer than natural light during the middle of the day.

Daylight is considered neutral light, with a color temperature of about 5500K. Most household lamps have a much warmer tone (lower K temperature). If you take a digital picture of a white wall under tungsten lighting, the wall will have a reddish-yellow cast. Fluorescent lights can look greenish (unless they are a special daylight-balanced variety). Flash is balanced to daylight. Sunsets and late afternoon light can pick up a warm, yellowish or reddish tone. Overcast and rainy days can look cooler, or bluer.

Setting the camera's white balance control for the existing lighting conditions electronically compensates for the color of the light source. When the white in a scene actually appears white, then all the other colors will be more accurate as well (hence the name, white balance). There are usually several choices for white balance settings on a digital camera, including Auto White Balance (AWB), Daylight (commonly a sun icon), Cloudy (a cloud icon), Shade (side of a house), Tungsten (light bulb), Fluorescent (fluorescent tube), and Flash (lightning bolt). Some cameras also include a custom, or manual, function for precisely setting WB to existing lighting conditions.

Most of the time you will appreciate the way AWB adjusts for unwanted color casts. But AWB is an automated function based on averages, so it cannot perfectly correct all lighting conditions, especially those with mixed light. You may get better results if you select the correct color balance setting for the lighting at hand, such as Cloudy for an overcast day and Tungsten for household lamps.

You may also switch from AWB if you like the color of a sunset or other shooting situation, because that setting will process the scene to appear neutral. Setting Daylight balance will keep the warm tones, while the Tungsten setting will eliminate some of the warmth by balancing the yellow to appear white. Some D-SLR cameras will allow you to change the White Balance settings in small increments.

White Balance

Digital cameras have a control called white balance (WB) that can neutralize unwanted color casts in your pictures. Color casts occur because visible light consists of different wavelengths with different color temperatures measured by the Kelvin (K) scale. Every source of light has its own particular color temperature, or hue. Our brains interpret these various colors so that, in everyday life, we barely notice the differences between, for examples, direct sunlight and shaded light or tungsten light (a household light bulb). But the sensor in your camera is more objective and records these differences when making pictures.

Indoor household lamps can create a warm cast to a picture. AWB (Auto White Balance) may correct it, but in some cases you may want to keep the warm tones.

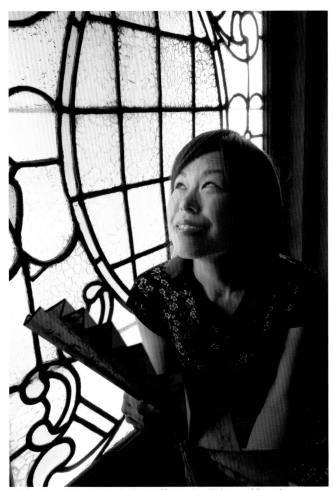

Notice how the stained glass affects the light, making the woman's face look quite warm.

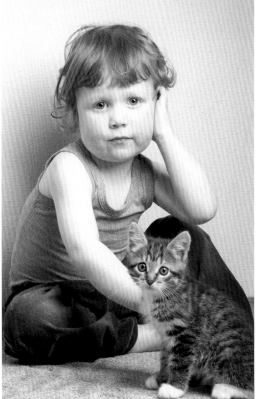

Unwanted color casts from lighting can also be cleaned up in image-processing software like Photoshop® from Adobe.

Portrait Basics

2

Good news! The quickest ways to improve your photographs are the easiest. Some might seem obvious as you read this book, but until you consciously use them in the field you won't realize their power. There are a number of proven and accepted techniques for composition (a fancy word for the design of the picture) that are important to understand for shooting good portraits (and, in fact, for making all other types of photos as well). We'll examine those in the next chapter. But let's start by looking at some basic portrait principles that are quick and easy to grasp. These simple ideas will give you a great foundation for shooting the kind of distinctive portraits that will make people take notice of your style.

In general, use the horizontal format only when your subject is in a horizontal position, like the girl above who has thrown her feet to the side.

Shooting Vertical

The first tip is straightforward. A person is vertical. As such, most pictures of a standing person or head-and-shoulders portraits should be vertical. So turn your camera sideways to take the picture! This will allow you to fill the frame with more person and less background.

There are only two main exceptions to this rule:

- Your subject is not standing, so they may no longer be vertical.

- There is a compelling design reason to shoot horizontally—such as you want to show a particularly beautiful or interesting background.

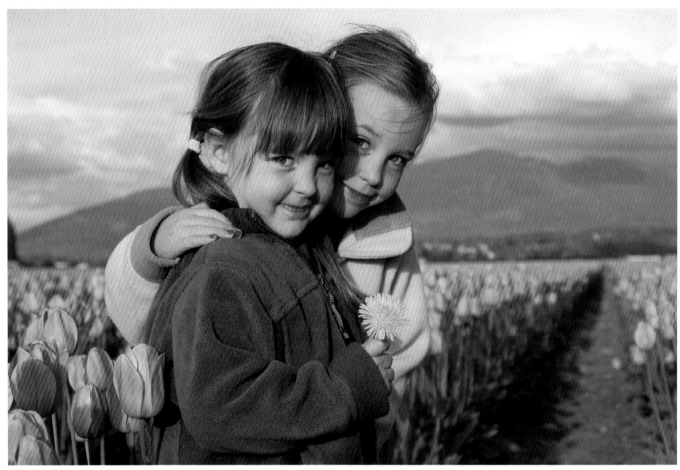

It is good to take a horizontal head-and-shoulders shot when you want to show the background, like the field of tulips in this beautiful mountain valley.

Background

And speaking of background, many portrait photographers wonder exactly how much of it they should include. The answer is to look for balance. If the background is ugly or just boring, crop most of it out. A portrait is about the person; so only include things that tell the story of that person or that moment in the person's life.

For example, the picture of a man and his grandson (opposite top) is about their enjoyment of a sunny day on the water's edge. Compare this to the view (opposite below) that shows more sky. Now the picture is more about the lake and the two people within a natural setting. Both are memorable pictures. And I consider both to be portraits because they tell us a lot about the pair. But they are very different interpretations of the same basic scene.

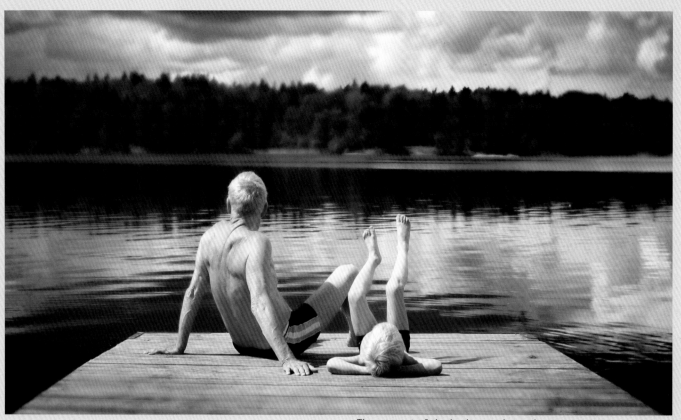

The amount of the background you show can change the emphasis of the picture.

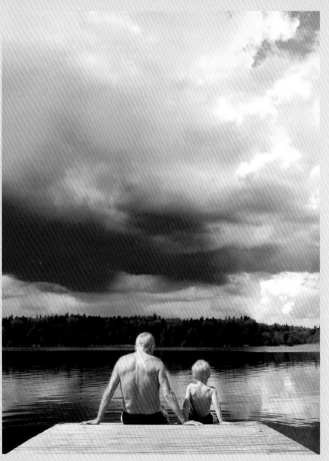

The Eye-Level Rule

Most pictures will look best if you shoot from your subject's eye level. With adults of similar height as you, this usually means you are both standing and you raise the camera to the height of your eyes. But when photographing taller or shorter individuals, you will have to move by either stepping up onto your toes (or a box or curb), or squat down a bit lower. Seated adults and children may require you shoot on your knees. And if they are lying down on the ground—well, you should be too!

As mentioned in Chapter 1, you can avoid some of these gymnastics by holding the camera lower and shooting without looking through the viewfinder. Some cameras with tiltable LCDs allow you to view the monitor while holding the camera at odd angles.

Though the subject in the pool is standing, the photographer outside the pool had to lie down to make this eye-level photo.

Breaking the Eye-Level Rule

I completely understand that I have emphasized how most portraits will look best if shot at the subject's eye level. It's simply the fastest

How Low Is Eye Level?

What does it mean to get down to eye level? Well, that depends where the eyes of your subject are.

If you're are a typical-sized adult, it means . . .

As an adult, you will have to kneel or squat.

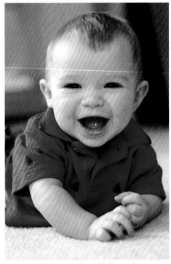

Try sitting, and still bend down even further.

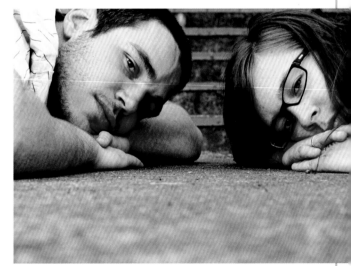

Lie down with your camera flat on the floor.

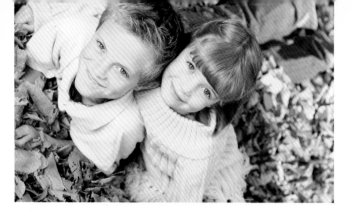

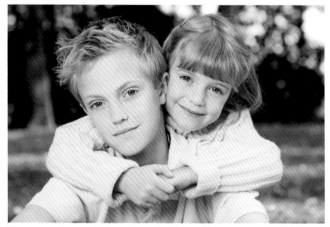

You can get very different results depending on your position. While looking down from above may create a cute photo (top), the most flattering portraits are usually taken at the subject's eye level. In this case, the photographer is in a squatting position to be even with the eyes of these siblings who are sitting on the ground. Notice also, how much younger the looking-down, distorted version makes the boy look.

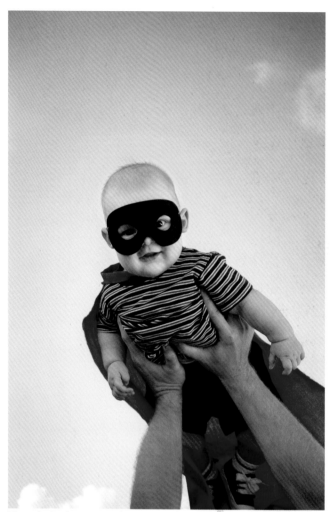

Though the best portraits are usually taken from the subject's eye level, there are certain situations where it pays to break the rule. This photo is a good example because the low angle emphasizes the flying height of this little superhero.

way to improve most portrait pictures. That being said, there are certainly times you may want to break this rule. Prime examples include:

- You want the distortions caused by shooting down at your subject with a wide-angle lens setting.

- You want to alter the background in relation to your subject.

 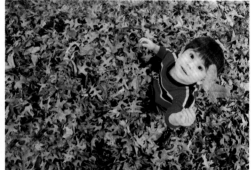

Looking down at your subject with a wide-angle setting can produce a bigheaded, cartoon-like image (left). But what about when you get really high (like on a porch shooting down into the yard) and really wide? Now you can emphasize the wonder of a pile of autumn leaves.

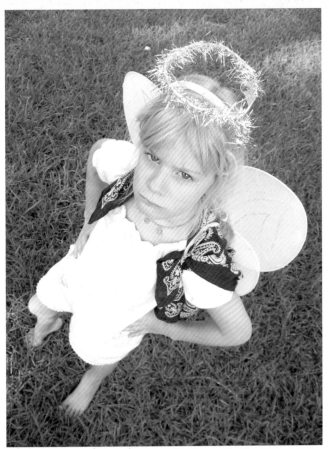

Looking down, with the addition of a disgruntled look, creates a funny fallen or grounded angel cartoon effect.

When to Point the Camera Down

There are several situations where you'll probably want to pick a high angle of view and break the eye-level rule. The first is when you want to highlight the relatively diminutive size of your child. Looking down from an adult perspective shows this.

Looking down also enables you to better see what a child may be playing with or holding. For example, we can imagine the city or other construction projects the girl in the sandbox may be creating (below). And the young cook's ingredients are clearly visible (opposite page), allowing us to almost taste the delicious dinner he'll be helping to prepare. Finally, looking down at the curly-headed girl and her pet (opposite far) lets us see how giant the bunny is, and how small she is.

It's a big world out there! And looking down at your child as she prepares to leave for school emphasizes her small size.

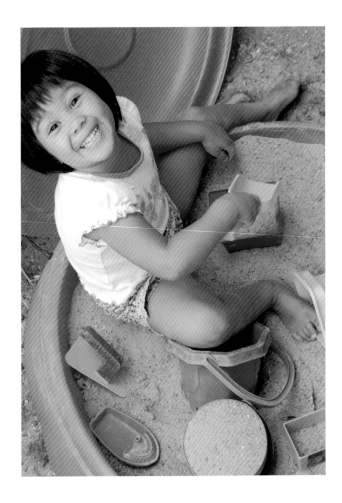

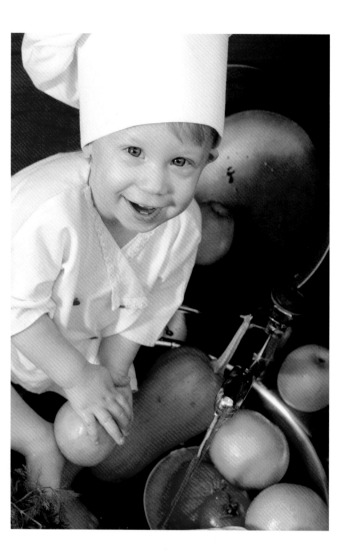

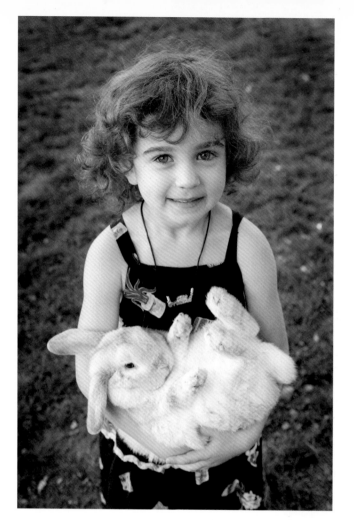

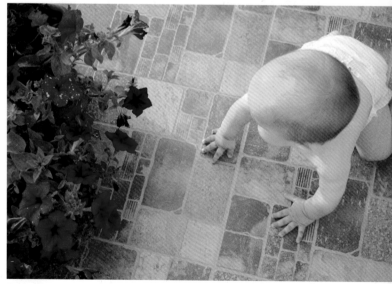

Going to an even higher perspective—a true bird's-eye view—where you are looking straight down gives portraits a disconnected, omniscient feel; like you are secretly viewing someone else's piece of the world (right).

A high angle shows us a bird's-eye view of this baby's world. She doesn't see us as she explores the flowers on her patio in the sunshine.

Looking down at a subject can make them seem smaller or more diminutive. Notice how this camera angle makes this young woman look more vulnerable.

Shooting from a slightly lower than eye-level angle (above, lower photo) can make your subject look taller and more powerful. The difference is subtle but apparent, compared to the image shot from a slightly higher vantage (top photo).

Traditional portrait photographers from days gone by often photographed women from a position slightly higher than eye level. This was because the vogue of the time was to make the "fairer sex" look more diminutive and child-like. Men on the other hand were often photographed from a slightly lower angle to make them look bigger and more powerful.

When to Point the Camera Up

There are also times when you may choose to break the rule about shooting at eye level to point your camera looking up. The most common reason to do this is to make the subject look taller and emphasize height. Or, if the sky is particularly beautiful, or the trees are in flower, you might choose a low angle to show the background. Sometimes a busy and distracting background can be avoided by using all sky.

A bug's-eye view of the world can be fun too. Try lying on your back and have your subjects peer at you, like you are a science project. It may be helpful to turn on your camera's fill-flash, because their faces will probably be in shadow against a bright background of the sky. (See Chapter 6 for more information on using flash.) Zoom to a super wide angle and have your subjects get even closer. The result turns comical because of the distortions, which may make your child look like a giant!

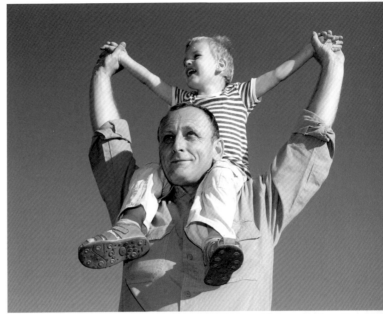

A low camera angle exaggerates the height of the subjects and gives the portrait a different feel than the standard eye-level shot.

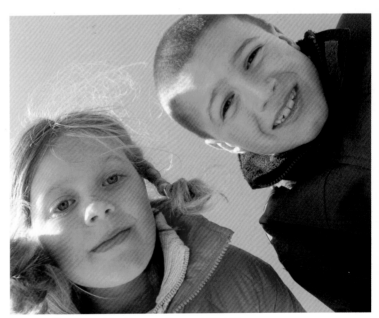

Lying on the ground looking up at your kids can create an amusing photograph.

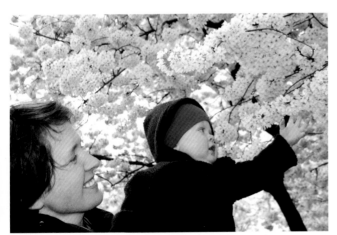

Sometimes looking up reveals a different background, such as a tree in full bloom.

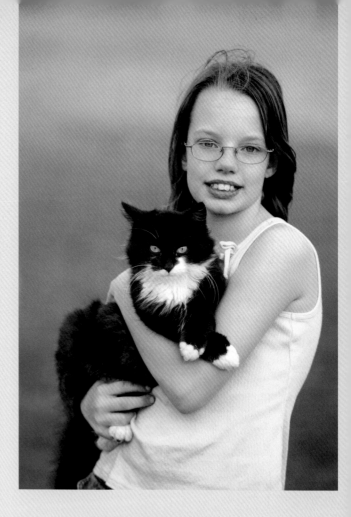

The girl is about the same size in both pictures, but the one on the left was taken up close with a wide-angle lens. This makes her face look wider than it actually is in real life. The image on the right was shot from farther away with a telephoto lens setting, a technique that yields a less distorted, more appealing portrait.

Lens Settings and Position

Most people shoot portraits from a fairly close distance to their subject. However, this is rarely the best way to shoot. Instead, take control of your lens and your shooting position. There are several ways that you can do this to radically control the outcome of your picture.

For one thing, you can create distorted images when you get close to your subject while using a wide-angle lens or a zoom at a short focal length. Often this distortion is so subtle that you can't detect it unless you're really looking for it. But it is there, and it will change the perception of the picture. The closer you are and the wider the lens setting, the more out of the ordinary your picture will look. Instead, step back and use a longer (telephoto) focal length for the most flattering result.

If the use of a wide-angle setting is taken to an extreme, the result can be funny or cute. You can make a silly face look even goofier, which is great fun for Halloween pictures. Super wide-angle lenses, like those available for some D-SLR cameras, can cause intense distortions—see the big feet in the picture below. And if the head is closest to the lens (such as looking down at a child or dog), that is what will appear out of proportion. This can give an adorable baby or puppy-face look to the picture.

On the other hand, some cameras (and D-SLR lenses) have incredible telephoto capabilities. This means you can magnify the subject in the viewfinder to a great degree. It also means you'll need to step much farther back from your subject than you're used to doing. It is not uncommon to be 30 feet (9 meters) away from your subject when taking a beautiful telephoto portrait.

Moving in close to your subject with the lens set to a wide focal length can enhance goofy expressions and add distortions to the facial features.

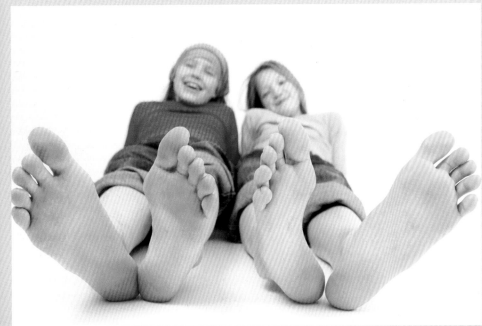

A D-SLR camera with a super wide-angle lens can produce extreme exaggerations. Objects closer to the camera (the girls' feet) become disproportionally larger.

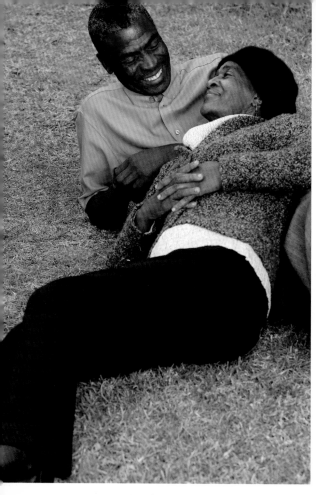

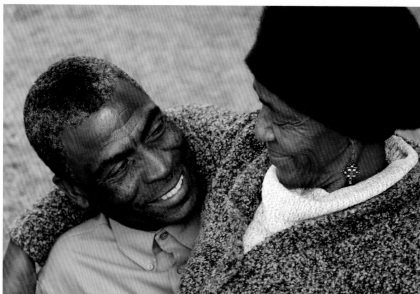

Zooming the camera's lens from wide (left) to telephoto (above) created two very different images of essentially the same scene. The telephoto shot isolates the couple from their background, and is more intimate.

Zoom In For Design

Stepping way back and zooming in to a telephoto setting usually creates the most flattering pictures of your subject. The reason involves complex optical science, but in simple terms, it flattens out the features in a natural and complimentary way. Using a D-SLR camera, you would zoom the lens toward the higher focal length, such as 200mm on an 18-200mm lens.

There are other reasons to zoom in and out with your camera, beyond avoiding or creating optical distortions. Sometimes the most interesting compositions are created by changing your shooting position and/or your zoom settings.

Look at the three photos of the girl sitting on a stone bench against an outdoor wall (opposite page). The top image was shot with the widest-angle lens and shows more of her setting than the others. The background is interesting and gives a sense of place. The middle picture was shot with a more standard focal length. The light pattern on the wall becomes a bold graphical design element in this one. The telephoto image (bottom) of just the girl's face is more of a traditional portrait. All three are wonderful images; yet they are very different from each other.

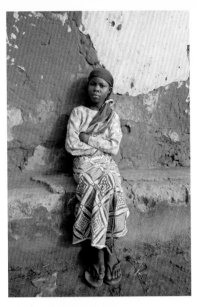

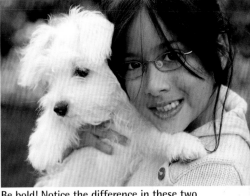

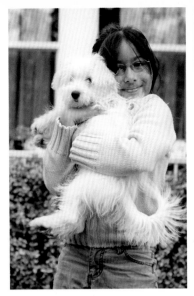

Be bold! Notice the difference in these two photos when the photographer zoomed in to fill the frame, eliminating some distraction in the background and focusing on the most important elements in the photo—the girl's face and that of her dog.

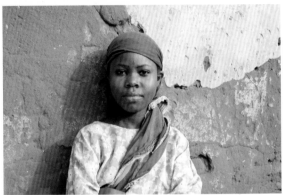

Changing lens settings and shooting position created three portraits. Each has a different feel, created by showing differing amounts of background as the subject's size within the frame changes.

Fill the Frame

Unless you have a compelling reason to show the background, always try to "fill the frame." This is a photographer's term for creating a picture where the entire image is filled with just your subject. There are three ways to do this:

1. Zoom your camera to the telephoto setting, or if you are shooting with a D-SLR camera, switch to a longer focal length (like a 100mm or 200mm). This will magnify your subject in a way similar to using binoculars.

2. Step closer to your subject. This will make them bigger in the viewfinder and on the monitor.

3. Try doing both to deliver the best results.

Start by eliminating all the unwanted background. Don't forget to turn your camera into a vertical position if the photo calls for this format. After you do this, look at the picture on the monitor. Then ask yourself, "Do I need the whole person's body in the portrait, or all that background?" The answer is probably, "No." If so, get even closer with your lens, your camera position, or both.

The swimming pool portrait (right top) is fine, but notice how much stronger the portrait becomes when you get even closer (lower photo). In addition to creating a better composition, the picture feels more intimate. It also makes the heads bigger, so you can see the details of their eyes and other facial features.

It's tempting to show the whole body when taking a portrait, but is that the best decision? The boy in red (below left) has a good pose, and the background is nice and simple. But do we really need to see his whole body? Just zooming in will create a much stronger portrait.

Compare the trio of pictures of a mother and daughter (opposite page). The first shows them from a distance (top). The middle one shows what zooming would look like. In the bottom picture, the photographer physically moved closer instead of zooming the lens. The difference may be slight, but the bottom image makes their faces look a little wider and the daughter's nose a bit bigger. Small nuances like this can have a big effect on your final image.

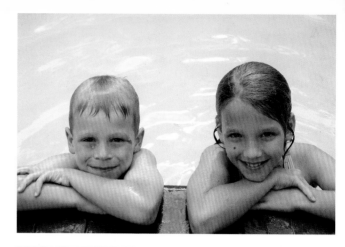

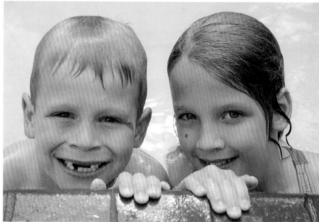

In the top portrait, notice how the children are looking up. By zooming in and getting down to eye level (lower), the photographer creates an even stronger and more personal photo.

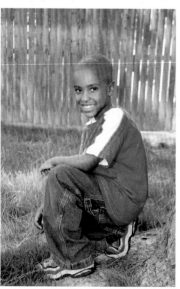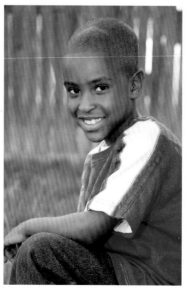

You don't need to have the entire body in the photo for it to be a good portrait. Don't hesitate to zoom in close on your subject.

You can even zoom in enough to fill the frame so that the background completely disappears and only the face is shown.

From a distance.

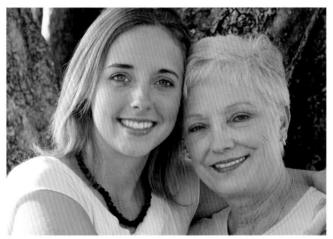

Zoomed in.

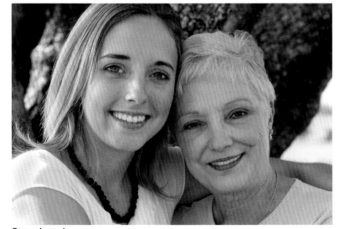

Stepping closer.

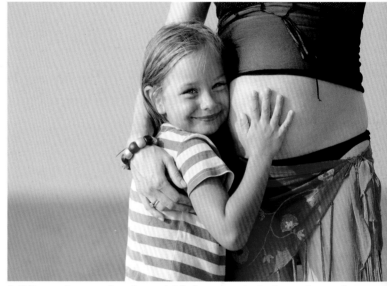

A little creative zooming changed this from a portrait of a mother and daughter to a portrait of a little girl and her soon-to-be-born sibling.

The picture above of a little girl next to her mother's pregnant stomach is a great example of creative cropping. The photographer zoomed in so much that all but the mother's torso is cropped from the picture. But that's okay, because this portrait is all about the happy little girl.

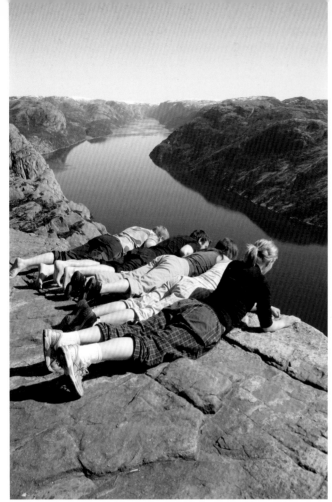

The relative height difference between these family members is not really as much as this wide-angle lens makes it seem.

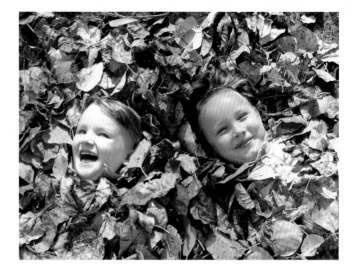

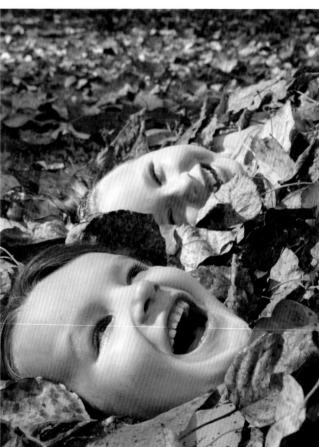

When shot at an equal distance from the lens, both of the children's faces are the same size (top). But put them at different distances and get in close using a wide-angle setting, and suddenly their relative sizes are radically different!

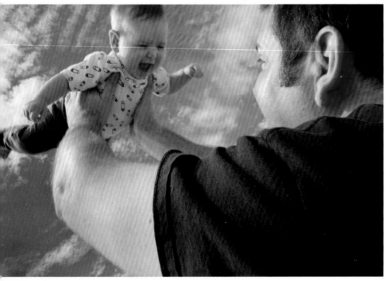

Because Dad is closer to the lens, he seems even larger than his child due to wide-angle distortions.

Size Relationship

As we learned earlier, a portrait taken with a wide-angle lens setting can cause distortions by making the closest portion of the picture look disproportionately bigger (see page 36). And in the photo of the family peaking over the edge of a cliff (opposite page, far left), the closest person looks much bigger than the others, but in reality, all the people are about the same height.

However, the same quality can be used to emphasize the parent-to-child size difference. For example, in the picture on the opposite page (lower left), a father is helping his baby son "fly." Because the photographer moved in close to the father with a wide-angle lens setting (such as 18mm on a D-SLR camera), placing the child farther away, their size relationship is distorted in a way that improves our enjoyment of the picture. The closer you get to the foreground person, the greater the difference in size.

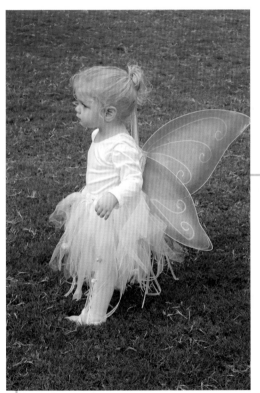

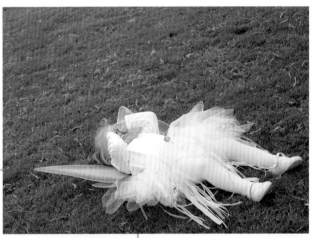

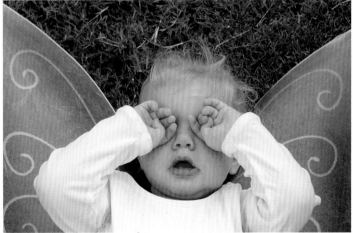

Go With It!

Shoot what life presents. You wanted that perfect portrait of your little fairy angel, but she isn't in the mood to stand and smile? Turn it into a funny portrait series that captures the ups and downs of childhood.

Composition

3

In both photography and other fine arts, the topic of composition deals with the design of the piece of art. In photography, it defines ways that you can improve your pictures, based on classical interpretations of art and form. The rules of good composition have been around for centuries—long before the advent of photography. They can, of course, be broken successfully. But in general, following accepted principles of composition will yield the strongest overall photos.

Any picture is made up of visual elements. In a portrait, some are more important than others. Usually the most important elements are the eyes. Secondary elements include other important body parts (like hands, especially if they are holding something), the horizon line, and significant foreground and background items.

If you separate the important visual elements in a photo, your eyes dance from one point of interest to another around the picture. If you measured the amount of time a viewer spends looking at a picture's multiple points of interest, you will find it is much longer than average. This ability of a photograph to hold a viewer's attention is called visual excitement, and the best pictures have it. Let's look at some of the ways you can create and incorporate this type of visual excitement into your portraits.

The Rule of Thirds

Where you decide to place the important visual elements in a photo can make a huge difference in how successful an image is. For example, a picture where the subject's eyes are exactly centered in the frame is rarely a strong photo. But take a look at the photograph on the opposite page, and notice that the eyes are not in the middle, but are closer to the upper right side of the frame. There is a great deal happening in this picture in terms of composition (see page 51), but the position of the girl's eyes illustrates the Rule of Thirds.

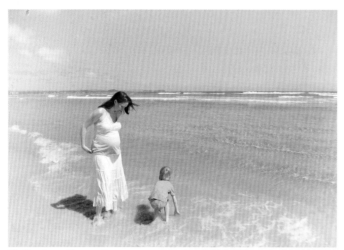

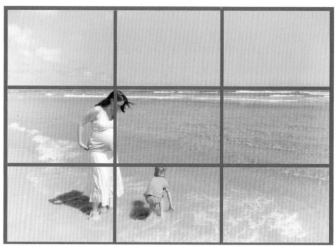

Notice how the mother, son, and horizon all follow the Rule of Thirds in this horizontal picture. This rule can also apply to vertical portraits.

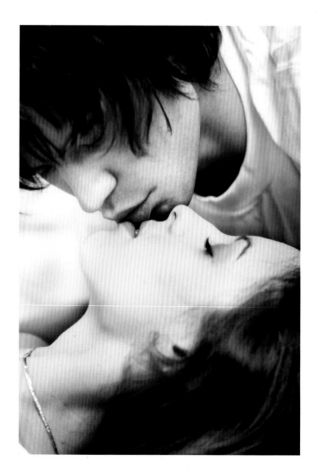

The Rule of Thirds is a guideline that will help you create balanced, off-center compositions. Begin by imagining your viewfinder or monitor divided as a tic-tac-toe board, with nine equal sections. This grid divides the frame into three columns and three rows. If you place important picture elements on these lines (and preferably on their intersection points), you'll end up with a more balanced design. Since the sections are equal in size, it works just as well on vertical compositions as horizontal.

Once you become comfortable with this concept, you can break it for artistic reasons. Most commonly, this is to take the rule to even further extremes—elements can be moved even farther off center.

However, having explained about the advantages of placing subjects away from the middle of the frame, there are certain situations when you will want to center the composition. Though it tends to make the photo more static, do it if that is your artistic goal. Symmetry is a good example. The romantic portrait of the young couple (right) is a fairly symmetrical picture. The symmetry in this case is diagonal, from the upper left corner to the

lower right corner, with the couple's hair "reflecting" each other as if in a mirror. However, the woman's eyes and lips are fairly centered in the picture. Is this still a successful portrait? You bet! This centering and symmetry in the picture communicate the stability of their loving bond.

In or Out?

Another compositional rule deals with portraits in which the person is not looking at the camera. You need to leave room in the frame for your subject to look or move into. For example, in the beach portrait below, the young woman's body and eyes are pointing to the left, so the most successful composition puts her to the right of the photo, where you can follow her gaze as she looks all the way across the picture.

You can simply tell older subjects which way you want them to move and turn. But for a baby, you may need to recompose the picture. Don't forget to use Focus Lock. Any time you move the subject significantly off center, you risk the chance of the camera focusing on a more distant background instead of the subject.

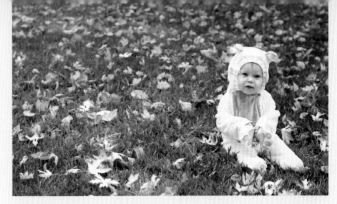

Look at these two pictures of a Halloween baby. The photographer has cleverly placed him to the right in both. This makes him look small and shows off the expanse of autumn leaves. But notice the two variations. The best picture is the one below in which the baby's feet and body are pointed into the center of the frame. Just that little change makes a huge difference.

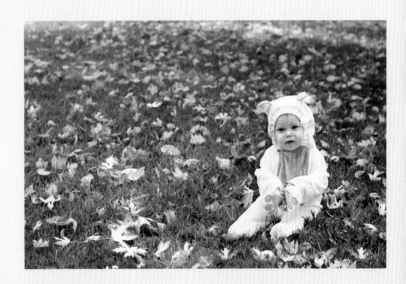

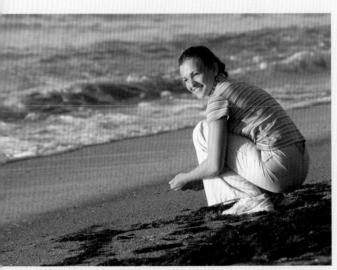

This woman's head and body are turned toward the center of the picture, where she is looking. We want enough space to follow her gaze.

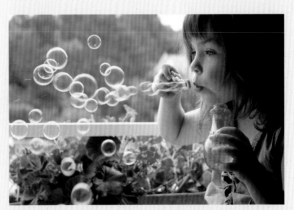

When taking profile photographs, it is especially important to place your subject to the left or right side of the frame so they are looking or moving into the open space. Here, the little girl has room to watch her precious bubbles float away.

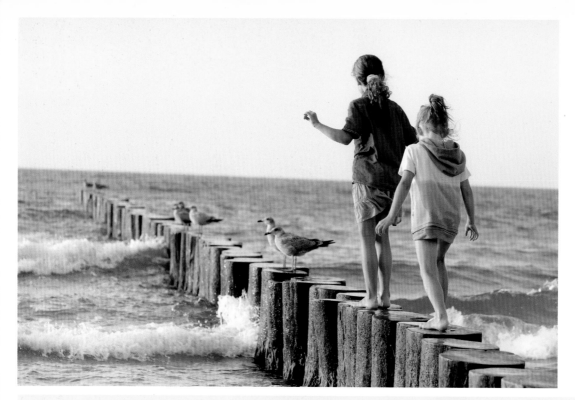

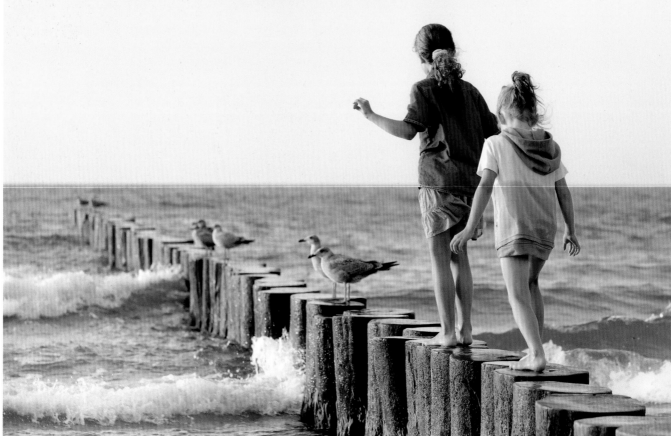

Even if a viewer can't place their finger on the cause, the slight tilting of the horizon line (2 or 3 degrees) in the top photo can make them feel "something" is wrong with the picture. The lower photo, with a straight horizon, shows the difference when a small adjustment is made in an image-processing program.

The Horizon Line

Try to move the horizon line away from the subject's eyes for the best results.

The horizon line can be an important picture element when it is seen in a photograph. In landscape and scenic photography, it is immensely important and is often placed high or low in the picture to follow the Rule of Thirds. In portrait photography, however, it can be a distraction. Why such a difference? Because in portraiture the horizon line is of secondary importance, and it is a very graphical picture element that can pull your attention away from the your subject if put in the wrong place or put slightly askew.

Compare these two beach portraits of the woman with the pink flower in her hair (right above). In the upper image, the horizon intersects with her face at exactly eye level, which creates a distracting result. In the lower, the horizon is below her eyes and therefore less distracting.

Purposeful Tilts

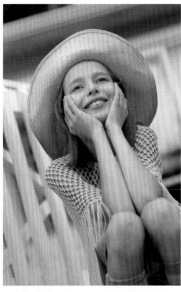

A picture from a camera that is slightly tilted can be disconcerting. We are used to seeing the world straight, and the tilted line feels wrong. It is easy to correct in image-processing software, but you will lose some of the outer edge of the frame when you adjust the image rotation and then crop to straighten.

A tilted picture can often add flair to a portrait by introducing diagonal lines and unusual angles.

This doesn't mean your camera needs to be level every time you shoot. Taking purposely tilted images can be a very effective portraiture technique because it adds diagonal lines and a bit of excitement. But in general, if you do it on purpose, do it boldly! Tilt the camera significantly.

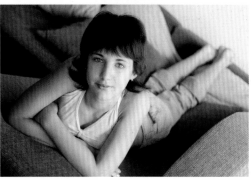

Other Types of Lines

Diagonal and curving lines are considered much more dynamic than a strictly horizontal or vertical line, and adds liveliness to a picture. The best type of lines help to accentuate important picture elements by drawing our eye back to them. The lines can be bold and obvious, like the curving white towel in the portrait of the boy to the right, or the line of a fence (below right). Circular or triangular compositions are generally the richest, because they create an endless loop that has our eyes dancing all over the picture.

The curving line of the towel echoes the curving line of the subject's eyebrow and lips in this dramatic portrait.

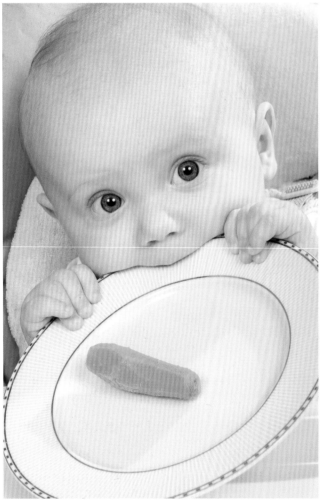

The photographer used a wonderful mixture of a tilted camera, strong diagonals (the carrot and the line of the eyes), and curves (the plate) for an endearing baby portrait.

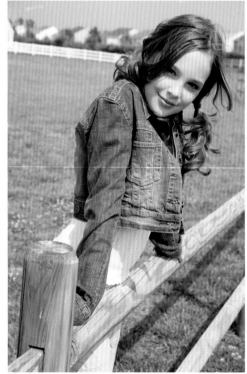

Shot at an angle, a fence becomes a bold diagonal line. Diagonal lines usually give the picture more energy than straight vertical or horizontal lines.

These visual elements can also be much less obvious, as in the photograph of a girl and her pumpkin that opened this chapter. The subtle visual lines hold together the important picture elements, as demonstrated in the yellow oval shown on the picture below. Most viewers' eyes do the following:

• Start at the girl's eyes,

• Travel down the pigtails to her hands,

• Go through the pumpkin and up its stem,

• Cross over to her toes,

• And drop back down to her eyes to start all over again.

The more time you can keep the viewer's eye traveling unconsciously around your picture, the more successful it is.

Control Your Backgrounds

You can significantly alter your horizon line—or just about any background—by changing your shooting position. Walking a circle around your subject will give you a lot of choices. So will going higher or lower.

A good exercise is to take your picture and review it in the LCD monitor. Ask yourself, "Is there anything in the background that I don't like?" If so, most likely it is a distracting element like bright colors, highlights, words, or graphic lines (or a combination of these). Try to find a camera position or lens setting that will reduce or eliminate the distractions. The difference between good photography and great photography is taking the time to do this kind of analysis and then shooting again.

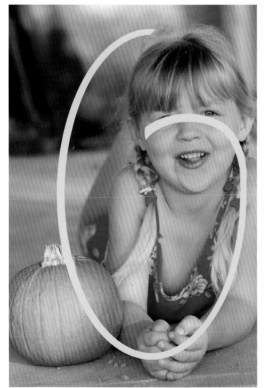

This picture (seen larger on page 44) has several great picture elements—the girl's eyes, hands, the pumpkin, and the toes. They create a visual circle that keeps us interested in the photo for a long period of time.

Make sure you are aware of what is in the background when taking pictures of people. Bright colors or a ferris wheel growing like a halo around your subject's head can be very distracting.

Simply adjusting the shooting angle changed the background from grass (above, looking down at the subject) to sky (below, looking up at the subject). Both look great, but they demonstrate how radically you can transform the background merely by altering your shooting angle.

Distracting elements occur not only in the backgrounds of pictures, but can be a part of the subject, as in the bright highlights on this woman's hands. They take our attention away from her eyes.

Not Just Backgrounds

Don't forget to check your foregrounds, and even your subjects, for distracting elements. In the photo above, highlights are visible on the woman's hands. These bright spots naturally draw our attention—and that's bad, because we want the viewer to look at her eyes. Don't believe me? Cover the highlights for a moment with your fingers and see if it improves the picture.

Studio portraits are popular because the backgrounds can be kept extremely simple.

Harmonious backgrounds that echo color in the subject's face or clothing can create a comfortable feeling in the photograph.

What Makes a Good Portrait Background?

Now that you have a good idea about what makes a bad background, the question arises: What makes a good background? For portraiture, it should be one or several of these following things:

• Simple: It does not rob attention from the person in the photo.

• Harmonious: The colors or shapes complement the person.

• Graphically Interesting: It introduces an exciting graphic element to the picture, such as bold shapes that do not distract.

• Story Telling: It tells us something about the person's life.

• Place Setting: It tells us something about where the person is at the moment.

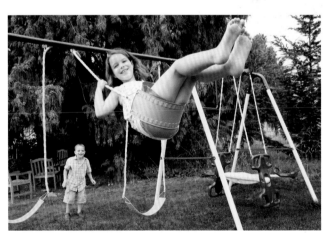

The background here is rich because you have a surprise—a little brother ready and willing to give his sister another big push.

Framing

Framing your subject is another fun technique that brings special emphasis to the person. It can be quite literal, such as placing them in a window frame or having them play peek-a-boo out of an apple grove or from behind a steering wheel, where a foreground element is used to encircle the subject. Framing can also be more subtle, like the way the reflections of trees create an arch around a grandfather teaching the grandkids how to fish, or the distant railroad suspension arch that frames a man's face and emphasizes it as he turns back to say goodbye.

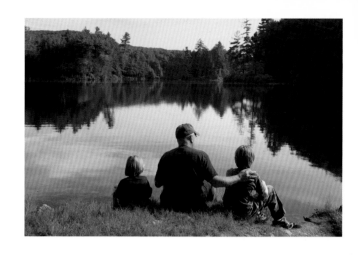

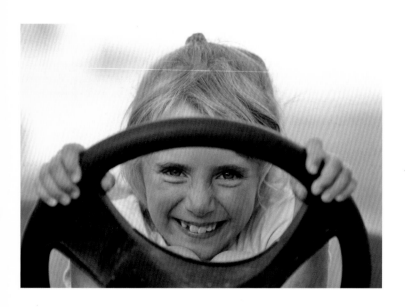

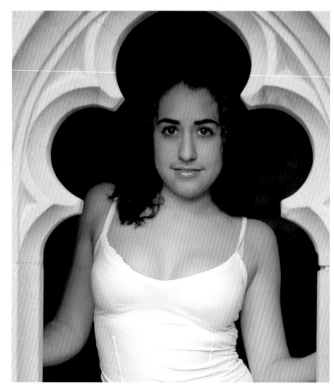

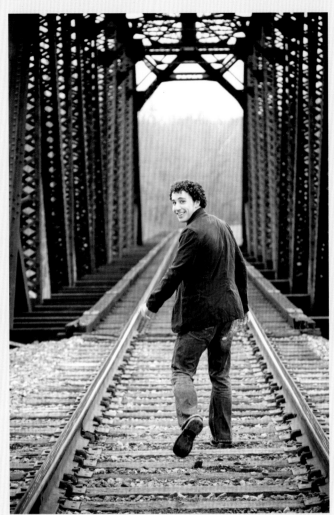

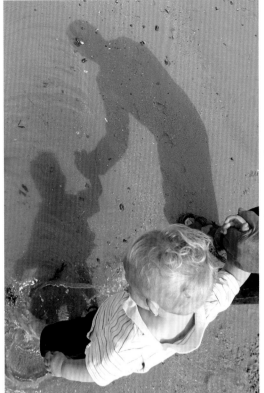

Sometimes you can turn a shadow into one of the most important visual elements in a portrait. It can also work to anchor a person in the photo, so they look balanced in the picture frame.

It can be a lot of fun to look for (or create) frames for your subject. They can occur naturally like the reflection in a lake, or an arching train trestle. They can be bold, or even funny.

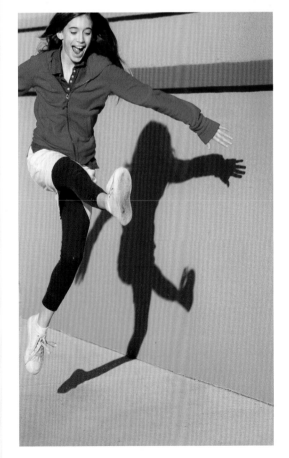

Shadows

We'll learn more about shadows in terms of their effect from lighting. But for now, here is a quick, illustrative introduction to their compositional value: They usually either anchor a picture or take on a life of their own.

Light and Portraits

4

Except for the subjects of your portraits, the type of light you use is the single most important aspect when making pictures of people. Light can make a person look beautiful or ugly. It can add excitement and drama, or set a mood. And it can accentuate or hide the features of a person's face. To understand how to use light for better portraiture, you need to understand that light has certain qualities. These qualities include hardness or softness, direction, and color.

Hard or Soft Lighting

First and foremost, light can be described in terms of its hardness or softness. Hard light produces hard-edged, dark shadows. Soft light produces soft-edged shadows that are less deep. Extremely soft light can be almost shadowless.

Bright sunlight on a clear day is the best example of hard light, which travels directly from the source to the subject. At its best, a portrait shot in bright sunlight will have rich colors and deep, dark shadows that can accentuate shapes and textures. These factors can combine to make an ordinary picture seem bolder and more graphic. At it's worst, it can look harsh and hide details in dark shadows.

Outside, should the clouds roll in, direct sunlight will have to pass through them to reach your subject. This diffuses the light and makes it softer, striking the subject from a number of different angles. The heavier the cloud cover, the softer the light. Shadows now become softer, and details on the shadow side are now visible. Shade has a similar effect.

In general, soft light produces the nicest, most complimentary portraits and is the best for rendering skin tones. There are, of course, exceptions. You can take great portraits in bright sunlight. It's just a little more dificult and yields a different result.

I usually advise that you start with soft lighting. Move into the shade or plan your shooting on days that are slightly overcast.

Soft light (such as that found under cloud cover or in open shade) usually results in the most pleasing outdoor portraits. It produces soft-edged shadows that are much lighter than those produced by hard light.

Direct sunlight creates deep, dark, and hard-edged shadows. This is not usually your best choice for portraiture.

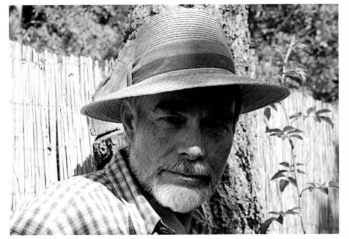 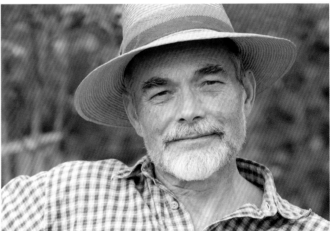

Notice how much easier it is to see the details in this man's face when he is photographed under softer lighting (right).

Eliminating Shadows

If you discover unattractive shadows on your subject's face, one solution is to have the person turn into the light. In some cases this means you have to rotate your camera position as well. In other cases, it just means you should work out the composition so your subject's face turns upward. Notice how the girl's face (below) is pointing slightly downward.. This compounds the difficulty to properly light her because turning the head down casts heavy, unattractive shadows around her eyes and under her nose and lips. Compare this to the portrait at the bottom of the page in which the subject is gazing upwards toward the light source. It is much more pleasant.

Soft window light reveals the three-dimensionality of your subject in an attractive and less harsh way than direct sunlight or your camera's built-in flash.

Try Window Light

Window light can be very attractive. For hundreds of years, European painters placed models in front of north-facing windows because of the indirect, soft sunlight that streams through for most of the day. Windows facing other directions can work as well for soft lighting, as long as the time of day is one when direct sunlight is not coming through. Beware of buildings that have a large overhang, however, because that may block too much of the light.

Top lighting can cause unflattering, dark shadows around your subject's eyes if their head is tilted down (above). If your subject raises their head slightly to look upward, these shadows can be avoided (left).

The sun striking this model's face has created a highlight on her nose that draws attention away from where we want it: her eyes.

Turning the model so that much more of her face is in shadow eliminates the highlight on her nose.

Now, moving our model entirely into the shade evens the lighting and eliminates the dappling effect altogether.

Dappled Light

Watch out for the dappled effect where uneven patches of light and shadow show in your image. This is caused when the light source is partially obstructed in some way. It can create unwanted highlights on the subject's face, for instance. Because our eyes are drawn to the brightest part of any picture, this can focus undesired attention to the wrong places. In the picture (top left) of the woman in blue, notice how the light shines on a portion of her nose. Our eye goes right to that bright spot, and not to her eyes (a much more important feature). Turning her body so her entire face is shaded helps improve the way the light falls on her face (top middle). Moving her into shade improves the picture even more (top right).

Dappled lighting is caused by objects that partially block the light. It can be a mixed blessing because it can detract or add to the appeal of a photo.

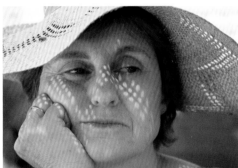

The pattern from the lady's hat (above) diverts the viewer's attention, while the diagonal lines on the man's face (left) graphically enhance the image.

Dappled light and shadow patterns can either help or hurt a picture. Patterns of light falling through a straw hat cause distracting highlights in the photo to the right, above. However, the stripes created on the man's face by Venetian blinds lend graphic interest to the portrait (right lower).

For the best results with dappled light, try to place the eyes or other important features of the subject in the brightest light. This is because the viewer's look will be attracted first to the highlights in a picture—and it is best if you are attracted to the subject's eyes.

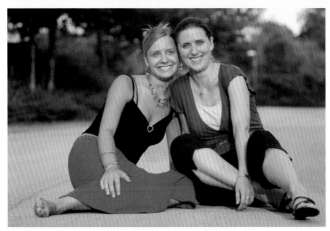

Dawn and dusk often have a mixture of warm and cool light, depending on the atmospheric and weather conditions. The light can appear bluish just prior to sunrise or after sunset.

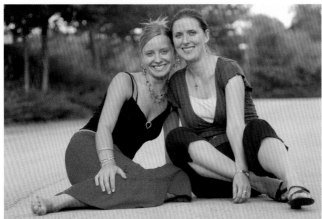

Outdoor lighting can change quickly. In the top image, the photographer caught the beautiful glow of the last rays of sunlight. By the time the photographer took the lower portrait, the special quality of the sunset's light had already disappeared.

Late afternoon sunlight often takes on rich golden tones.

The Color of Light

In addition to hardness or softness, the light's color has a big impact on a portrait. Remember from our discussion about white balance (see page 24) that every source of light has its own hue, or color temperature. It is important to look carefully at the light, and recognize unusual, non-neutral colors. In some situations, you may like the way a color cast looks, such as golden light in the late afternoon. At other times, you may want to neutralize (eliminate) the color cast through white balance controls..

Winter mornings and evenings can have pink and blue hues.

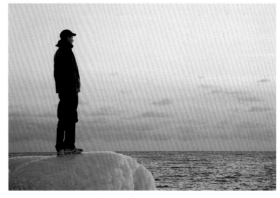

The Direction of Light

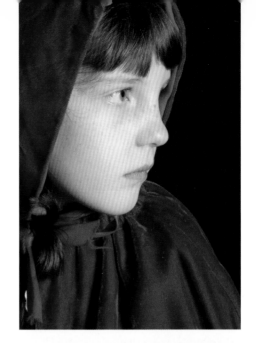

We can't control the sun, but we can control what time we shoot and how we position our subject relative to the sun. And with other types of light, such as flash, household bulbs, studio lights, or even candlelight, we have a lot of control, particularly in determining at what angle the subject will be illuminated by our light source.

For example, look at the Little Red Riding Hood portraits to the right. The girl is looking into the light in the top photo, so we do not see shadows on her face. This is far more pleasing than a portrait with shadows, as demonstrated in the lower photo, where the girl has made a quarter turn away from the light to face the camera. The light has not moved, but now it is coming from her left side (which is also on the right side of the camera). An experienced studio photographer would probably add a fill light to the other side of the girl (camera left), which would improve the picture by lightening the shadows on the that side of her face.

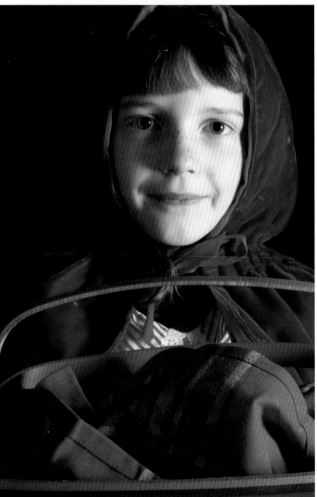

This dramatic portrait uses a single direct source of light to create hard shadows that sculpt the face.

The lighting didn't change in these two portraits—just the model's head position, creating shadows on the right side of her face when she looks straight at the camera.

Backlighting without any front fill light will produce a silhouette.

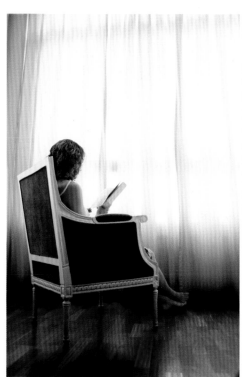

A window can produce backlighting if you point your camera at it. Here, using plus exposure compensation achieves detail in the woman, instead of allowing her to become a dark silhouette. (See pages 112–113 for more on exposure compensation.)

The examples on this page and the next are the most common lighting angles for portrait photography. In advanced studio lighting, multiple lights are often used—usually a single main light (the strongest) and one or more lights or reflectors added for filling shadows or adding highlights.

Front Light

If the light is from behind the camera and in almost the same direction as the camera lens, then the lighting will be "flat" because the shadows are not visible (whether it is hard or soft lighting). A variation is high front, which will cast a shadow under the subject's nose in a portrait.

45° Light

Move the light 45° off the axis of the camera, and the shadows will fall to the side and become more visible to the camera.

Side Lighting, Facing Camera

With the lighting from the side, you may see strong shadows if the model is facing the camera.

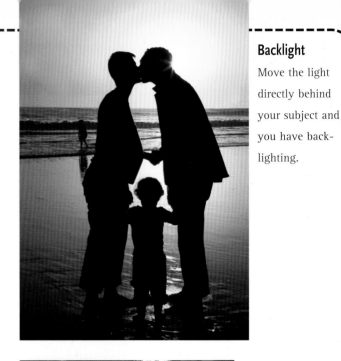

Backlight

Move the light directly behind your subject and you have back-lighting.

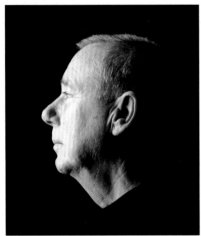

Side Lighting, Facing Light

If the lighting is from the side, you can have the model face the light and photograph their profile.

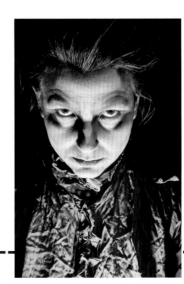

Backlight with Fill

If you don't want a backlit portrait to become a silhouette, you can add fill light with a flash or reflector. Alternately you can increase the exposure using plus exposure compensation. This will result in a properly exposed face, but the background may become too bright.

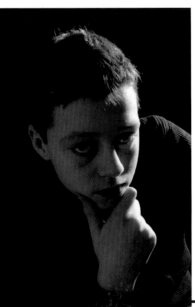

Rim Light

Rim lighting is when the light source is slightly to the side and behind, creating an outline of light.

Bottom Light

This type of lighting is not usually found in nature, so it looks "odd" for portraiture. As such, it is a favorite of directors who make horror movies.

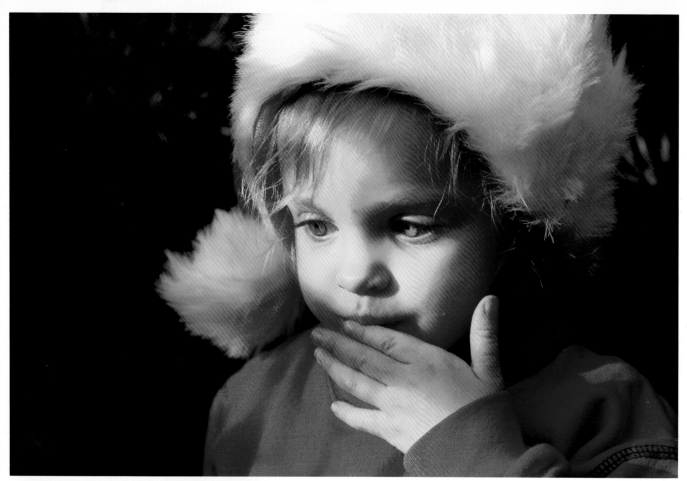

Using the Sun Outdoors

The sun can cause harsh shadows on your subject's face, especially at noon when the sun is at a high angle. Here are four ways to improve your sunny portraits:

1. Put the sun at your back, so your subject is lit from the front. However, you may still get harsh shadows on their face and squinting eyes.

2. Move into the shade.

3. Wait until the angle of the sun is lower in the sky than "high noon" (afternoon, early morning, or winter.)

4. Best yet, use fill flash. The subject can even wear a brimmed hat to reduce squinting, while the fill flash will light the dark shadow area under the brim. (More on that in Chapter 5).

When you see unusual or beautiful light, go ahead and place your subject in it. The light itself can be more important than the setting!

Flash and Portraits

5

Many people think of electronic flash as simply a way to supplement the available light in a scene. They don't realize that flash is a useful tool that will improve their photos, even brightly lit outdoor scenes. Electronic flash units are a creative tool that, when used properly, can take photography from mediocre and blah to exciting and compelling. Flash is especially useful for photographing people. When properly controlled, it can add to a portrait's drama and appeal.

Most cameras have built-in flash units, but these vary greatly in their capabilities. How these flash units function and their controls for lighting a scene also vary widely. These features are largely dependent upon the type of digital camera in use. Keep in mind when reading the descriptions that these are generalizations and your camera/flash may work slightly differently. But before we discuss how flash units work, we will explain some of the basic concepts that will help you understand how to improve your flash photography.

Flash photography is not simply for use indoors. It is a creative tool for all types of portraits, including when you are outdoors in shade and with backlit situations.

The Inverse Square Law

While it may sound like high school physics, this law is important because it states, "Illumination from a light source is inversely proportional to the square of the distance from the source." Put simply, this means that if you double the distance between the flash and the subject, the flash must emit four times as much light to maintain the same level of exposure. Thus, if your flash isn't adding enough light to the subject, you need to move closer, open up your lens aperture (if your camera allows this), or increase your ISO setting. If you are getting too much light from the flash, move back and zoom the lens a bit more, use a diffuser, close down your lens aperture, or change your ISO setting.

Remember, the Inverse Square Law also applies to backgrounds—if you want them to be lit by the flash. Thus, if the background in a photo looks like a boring black hole, it will help to move both yourself and your subjects closer to the background (a wall, a bush, a curtain, etc.). By doing this, you enable the light from the flash to reach and expose the background, which will usually improve the appearance of your photo.

Flash with Point-and-Shoot Cameras

Most flash units on these cameras operate in a basic automatic mode with some override capability on some cameras. All point-and-shoot cameras have an Autoflash mode in which the camera automatically fires the flash when it senses there is not enough light for a good exposure, and in some cases when the camera detects a backlit situation. This produces adequate results in most circumstances. However, there are a number of situations when you will want to take control of your camera's flash modes to produce the best pictures. These modes may include Fill Flash, Force Flash, Night Flash, and Flash Off.

The Wonders of Fill Flash

These various flash modes give you some creative control if you choose to use them. One of the most useful is Fill Flash mode.

One of the best uses of fill flash is when you are photographing people outside on very bright, sunny days. While it may seem strange to add more light when there is already quite a bit, fill flash actually evens out the light, reduces the overall image contrast, and makes colors pop. This is because it reduces the overall contrast by lightening the darker shadows. Fill flash should be used in bright situations where sunlight casts harsh, dark shadows on your subject's face. The classic example is a person wearing a baseball cap or other brimmed hat, and the shadow beneath it hides the details of the face.

Fill Flash mode works because the flash is set to a level that is weaker (less bright) than the non-flash illumination (usually the sun). So instead of eliminating the shadows, it simply lightens them. This makes the picture seem like it is lit with natural light, yet you can see details in what would otherwise be dark shadows. The photograph of the boy at right is a good example of the use of fill flash.

When you set Fill Flash mode, the camera always fires the flash, and, with more sophisticated cameras, the flash will be at a level that is less than the full ambient light exposure. In this way it lightens the shadows but doesn't compete with the natural light.

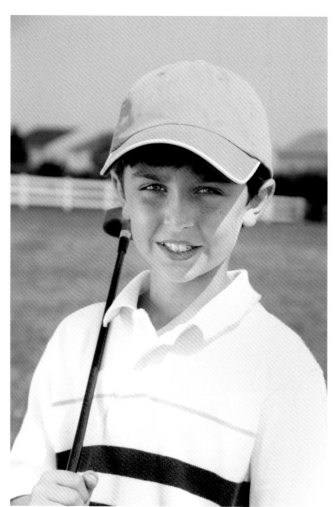

A successful fill flash exposure adds slightly less illumination than the existing light. This allows it to lighten the shadows on a subject's face without creating a flat, unnatural appearance.

Reflectors

Though not a flash, reflectors deserve mention in any portraiture book. A reflector is any object used to bounce light back at the subject. It helps to lighten shadows in a way similar to Fill Flash—except with the reflector you can change the angle and color of the fill light.

There are commercially available reflectors that collapse into a small travel case for easy carrying. A less expensive alternative is to buy white foam board from the hobby or art store, or you can even cover sturdy cardboard with crumpled tin foil.

The texture and color of the reflector can make a difference in the look of the photograph. White is the most common. Metallic reflectors (usually silver or gold) are more reflective than matte materials, so they bounce stronger, harder light back at the subject. Gold reflectors add a warm tone to the fill, which gives a sunset feel to some portraits.

Gold reflectors add warm fill light to the picture.

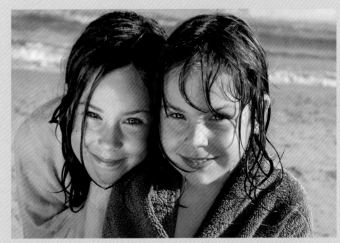

On sunny days, you can produce strong fill light by bouncing sunlight back at the shadow side of the subject with a reflector.

Force Flash Mode

With Force Flash mode, the flash tries to deliver enough illumination so that it becomes the main light source. This differs from Fill Flash, in which the flash is meant only to fill in shadows and not become the main light. The classic situation for using Force Flash is when your subject is positioned so he or she is lit from behind, and the background is much brighter than the face (a backlit situation). Shooting without flash would probably yield a complete or partial silhouette, with the person so dark that you can't see any features.

Backlighting occurs when the background is much brighter than the light on the subject's face, such as a person standing in front of a window or a sunny sky. If you don't supply light to illuminate the front of the subject, your camera might meter the background and create a silhouette.

Using Force Flash in a shady situation will make the subject "pop" out of the background. The flash becomes the main light, though the background, which is lit by ambient light, is also usually recorded.

Force Flash can also be used to brighten the subjects in comparison to the natural light. This tends to make your subjects "pop" out of the scene, therefore making them more dominant elements in the picture.

Night Flash

Night Flash mode is an excellent choice when shooting portraits at sunset, in front of a nighttime cityscape, or in low light situations. This combines flash with a longer exposure so that the background, which is not illuminated

Flash and Movement

If your background moves during a photograph taken with Night Flash (Slow Sync Flash), you can get wonderful, creative effects. The flash freezes the nearby subject, while the background blurs. Examples include a roller coaster ride, a playground spinner, or nighttime traffic behind the subject.

You can also create a different effect if the subject is moving in relation to the camera. The subject is momentarily frozen by the flash, but still blurs during the long exposure. This can result in ghosting at the edges. It can be a lot of fun to play with this special effect!

Since the photographer was also on this ride, the kids were not moving in relation to the camera. Night Flash lit the subjects while the background spun into a fast-moving blur.

In this example, the subject was running. The Night Flash froze him mid-air, but he still blurred during the long exposure and left black or "melting" effects on either side.

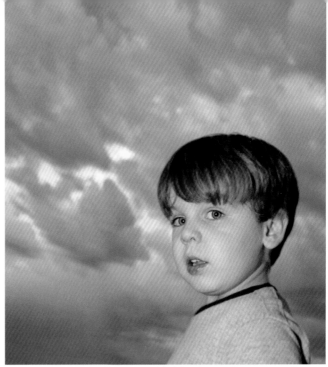

Without flash, this picture would either be a silhouette against the sunset or a well-exposed boy with a washed-out sky behind (depending on your exposure).

by the flash, will record on the sensor. Consequently, instead of getting a pitch-black background, you will record the sunset, city lights, or other scenery behind the subject.

A tilting head, found on some flash units that attach to advanced point-and-shoot cameras, allows you to bounce the light off a ceiling to give a softer lighting effect than a built-in flash. © Eastman Kodak Company

When To Use Flash Modes

Shooting Situation	Desired Effects	Mode Selection
Distant Subjects	Your flash can't light up a distant player at a baseball stadium. (For distant subjects, turn your flash off.)	Select Flash Off and hold camera very steady (or brace on solid object/use tripod).
Close-Up	Subject too brightly lit by flash due to close distance (1–2 feet, 30–60 cm).	Select Flash Off and hold camera very steady (or brace on solid object/use tripod)
Outdoor, Bright and Sunny	You want to lighten face shadows caused on subject's face (especially if they are wearing a brimmed cap).	Select Fill Flash if they are within range (3–12 feet, 1–3.6 meters, on most cameras)
Backlighting, Silhouette	Silhouetted person against a beautiful sunset or bright lights.	Select Flash Off and hold camera very steady (or brace on solid object/use tripod).
Backlighting, No Silhouette	Combine the effect of a colorful sunset AND see your subject's face.	Select Night Flash (may be called Slow Sync). If mode not on camera, try Force Flash, Fill Flash, or Autoflash (may not fire if enough light)
"Light" Is Your Subject	Photograph light itself, like a sunset, fireworks, neon signs, city lights, or a backlit stained glass window.	Select Flash Off and hold camera very steady (or brace on solid object/use tripod). This will reduce blur caused by a long exposure.
Eliminate Red-eye	Shoot in dimly lit situation without creating red-eye when using flash.	Select Red-Eye Reduction mode or add light to existing environment.

Flash with Advanced Point-and-Shoot Cameras

A number of high-end point-and-shoot cameras have capabilities and functions beyond the basic models. These may have a hot shoe for use with accessory flash units that offer a number of options not available with built-in flash, including several of the advanced functions described on page 75. However, these units usually do not allow the degree of sophistication in terms of metering and exposure found in accessory flash units dedicated to D-SLRs.

Flash with D-SLR Cameras

D-SLRs generally offer many more options than other types of cameras for creating great flash pictures. Most of today's D-SLRs have a convenient on-board flash and they also accept accessory system flash units. These cameras offer many choices in flash metering, different options for controlling when the flash is fired, and some even have a high-speed, stroboscopic flash mode. These options depend on the camera and flash combination.

D-SLR Flash and Camera Modes

Most D-SLRs offer a fully automatic "green" exposure mode where the camera will automatically fire the built-in flash if it determines it is needed. On the other hand, the creative metering modes such as Program (P), Shutter Priority (S or TV), Aperture Priority (A or Av), or Manual (M) give you total control over when flash is used (check your equipment instruction manual for details on specific features and functions).

You also have a choice in the way the flash exposure is measured. The best type of flash metering with a D-SLR is digital-TTL (or the equivalent). This mode is called D-TTL (digital-through-the-lens) because the camera judges flash exposure from the light that travels into the camera through the lens. This is the most accurate way to measure light because it sees what the image sensor will see when you take the picture. It measures a series of pre-flashes and determines the flash exposure based on reflectivity of the scene, the placement of the active focusing point, and other pre-programmed information.

Other modes are available, which you may want to try for creative purposes. However, D-TTL will generally give you the best results with flash in almost all portrait situations.

The Built-In Flash

The built-in flash is handy for quick flash photos but results are limited by the power and position of the flash. Light coming from directly above the lens is not the most flattering and can often cause red-eye. However, the built-in flash works well for fill flash with outdoor portraits.

If you find that the flash is too strong and overpowers the existing light, use minus flash compensation or move farther from your subject and zoom the lens to a more telephoto setting.

Accessory flash units for D-SLRs are more powerful than built-in units and can offer a number of creative possibilities for your portrait photography. © Canon USA, Inc.

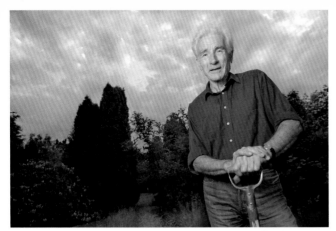

The flash illumination is coming slightly from the left of the camera. This causes a shadow on the side of the face and gives it graphic three-dimensionality.

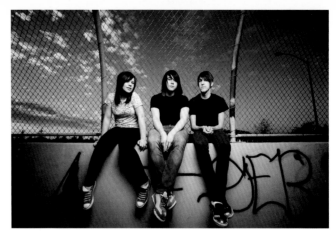

A flash unit was placed high above the camera to create a spotlight or street lamp effect for this band portrait.

Accessory Flash

One of the best things about a D-SLR camera is that it will accept accessory flash units. Most camera manufacturers offer a choice of several units with different power and features. These can be attached to the camera's hot shoe or connected with a dedicated cord. Accessory flash units have several big advantages:

1. They have a separate power supply and are more powerful than built-in flash units.

2. They recycle faster so there is little delay between pictures.

3. Most can be tilted, so they can be bounced off the ceiling or relfectors for softer effects.

4. Most can accept accessories that make the light softer and more pleasing.

5. Many can be used "off camera" with a dedicated cord or wireless system. This produces more pleasing light for portraits because the flash is not directly over the camera.

If you invest in an accessory flash for your D-SLR camera, be sure to select one that is dedicated to your digital camera model. This means it will communicate well with the camera's exposure and focusing systems, which results in better pictures. The best flash unit will be a

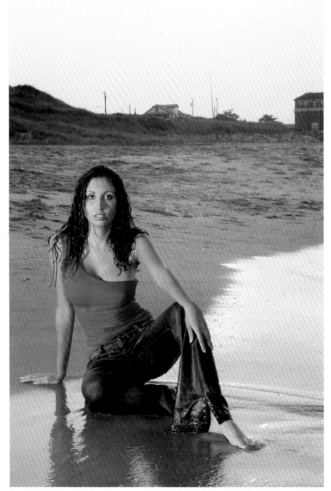

A remote flash placed to the side gives dramatic lighting that fits the sunset scene.

D-TTL (through the lens) type, which fires preflashes that are measured by the camera's microprocessor rather than by an external sensor on the flash unit. This usually results in better flash exposures, especially in tricky lighting situations.

Many dedicated accessory flash units can balance their flash exposure to the non-flash or ambient lighting. This means you can make the flash be the main (strongest) light while still recording the background (ambient light) exposure. This is the same effect as Night Flash or Slow-speed Sync mode on some point-and-shoot cameras (see pages 71-72).

You can also control the flash so it is less powerful compared to the existing light. In this case, it will merely fill the shadows or add a highlight to the eyes. This is often called fill-flash ratio or flash exposure compensation. Some flash units will let you set differing amounts of exposure compensation. This allows you to minutely change the amount of fill light the flash delivers.

Some cameras will automatically bracket the flash exposure, called flash exposure bracketing. The camera automatically takes several successive pictures using different flash exposure settings. This can be helpful when you want to quickly experiment with different settings. However, don't confuse this with autoexposure bracketing (AEB), which will change both the flash and ambient exposure.

Advanced flash units often have flash heads that can be moved to direct the light at different angles. Pointing the flash towards the ceiling or into a reflector card will create bounce lighting, which is softer and more pleasing for most portraits. Some accessory flash units can be removed from the top of the camera and held or placed to create different lighting effects, such as side or high front lighting. These units can then be controlled wirelessly by the camera or with a remote control. Several flash units can even be set to "sync" together to create a studio-style multi-light setup.

Accessory Flash Limitations

While some accessory flash units can be used at considerable distance, all have their limitations. Make sure you are aware of the range of the unit with the lens that is mounted on your camera. Using higher ISO settings can increase the range, but this will also increase digital noise. Therefore, it is unrealistic to think they can light up an entire amusement park at night.

Another limitation is wide-angle coverage. This is really only a problem when shooting with a D-SLR camera with a super wide-angle lens. The lens simply sees a wider view than the flash illuminates. The result is the spotlight-effect, where the center of the picture is properly exposed and it gradually falls off toward the edges. If your flash has a zoom lens or diffuser, this will help you to cover more area but will shorten the distance range of the flash.

Check the instruction manual for your flash unit's distance range. It may be limited to short distances at low ISO settings.

If the flash is not designed for the lens in use on a D-SLR camera, you may get dark edges to your flash pictures when shooting with a wide-angle zoom setting.

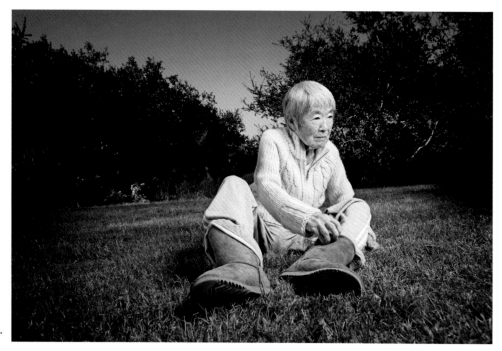

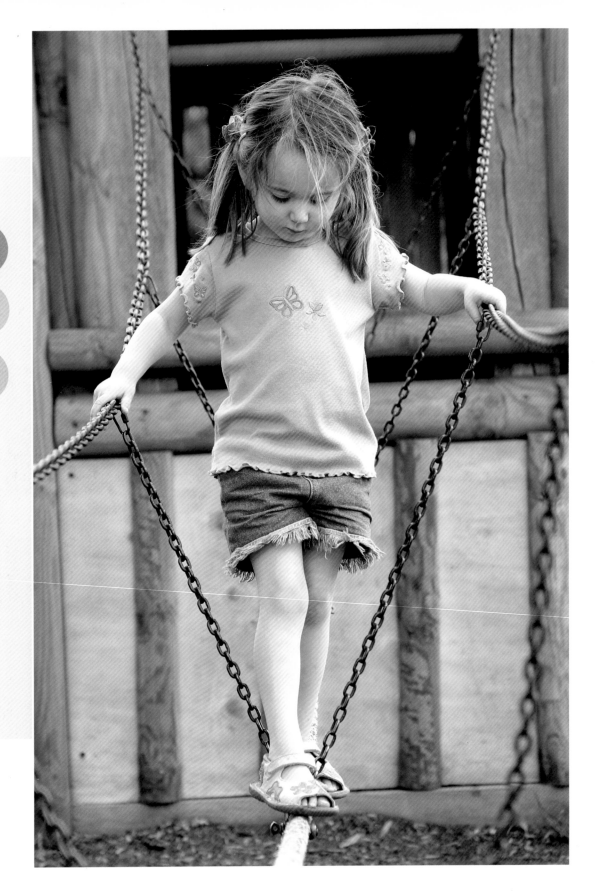

Portrait Styles

6

Let's take a look at how to make candid photos and gradually move into ways to set up more posed pictures. This is important because many of our potential models, and many of us photographers, cringe at the idea of posed portraiture. For the models, it is probably because they have had unflattering portraits taken in the past. (The pictures on pages 88-89 will help you get cooperation—and great photographs—from this type of person.) For the photographer, it is usually a reluctance to intrude on the person's privacy, the fear or embarrassment of having to show them a less than perfect portrait, or a combination of both. If you practice the tips in this chapter, these fears and reluctances will become a thing of the past.

Candids

I consider candid portraiture to be pictures taken at any time your subject is unaware of the photographic effort, or is so unconcerned by it that they ignore you. This gives you the luxury of playing with your camera controls and experimenting with new techniques without any expectations from the subject.

The easiest way to start is by zooming your camera all the way to the telephoto setting (or switching your D-SLR camera to your lens with the highest number focal length, such as 200mm). Then step back and watch your subject engage in everyday activities.

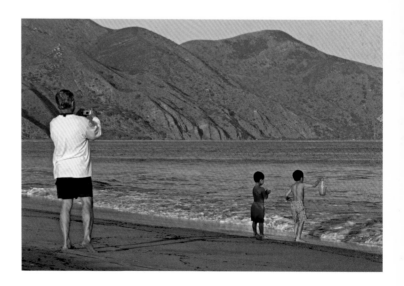

You can raise your camera to your eye and use the viewfinder. Or with a point-and-shoot camera (or even some D-SLR cameras that have a live-view LCD), you can compose in the monitor. Looking at the monitor gives you the added advantage of being more surreptitious.

Notice how the subjects in the beach photo and the garden bridge picture (right, above and below) aren't even looking at the camera—they are walking away. Is this still a portrait? You bet it is! Their eye contact is not with the camera, but with each other, and this adds a lot to the photo. We learn of their bond and a little bit about a wonderful day on the beach or in the garden.

The "little lion" picture below was taken with a telephoto lens and the photographer was able to crop tightly for a headshot. This little cub was unaware he was being photographed, thus allowing the photographer to capture a darling moment.

During a portraiture session, I asked this couple to walk back and forth along the beach of Lake Michigan, photographing them as the came towards me and as they walked away. I ended up liking this one best, because it portrayed a mood and a moment.

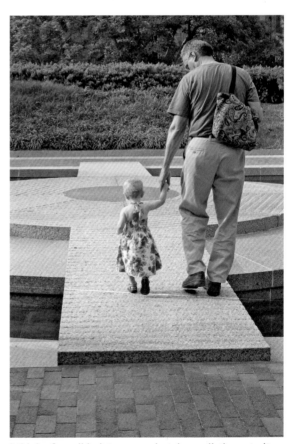

A telephoto lens setting enables you to take close-up portraits without being too close. This helps you catch moments when your subject is unaware of the camera.

I think of candid pictures as photojournalistic portraits. This tender moment tells the story of a grandfather and his granddaughter. Like the photo above, this shows that not all portraits have to be front views.

Practice shooting from your hip. Since you are not holding the camera up to your eye, few people will even realize you are taking a picture.

Use both extremes of your lens—move back and fill the frame with the telephoto lens setting, and then go wide for goofy portraits with the kids hamming it up!

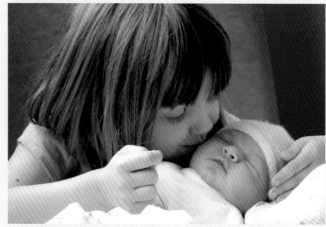

A stubborn model may never kiss her baby brother on command. But you may be able to catch a spontaneous moment by just pointing the camera and shooting.

Wide and Sneaky

When you move in closer to your subject, your physical presence makes it harder to take true candid pictures. You're simply more of a distraction—especially with camera-shy subjects. But you can still get great candid pictures even when you are close to your subjects.

I've mastered a sneaky method of casually aiming without my subjects even realizing I am about to shoot the picture. First I put my camera to the widest lens setting (a low focal length number) and move in close. The key is to hold the camera low, "shooting from the hip" without looking through the viewfinder or raising the LCD moni-

tor to eye level. Just try to aim the camera straight at your subjects and push the shutter release button. Sure, I get oddly framed shots often and occasionally I completely miss the person in the picture, but I simply delete those. The camera usually does a great job of focusing and exposing the picture, and every once in a while I get an absolutely incredible shot, making this technique worth the effort.

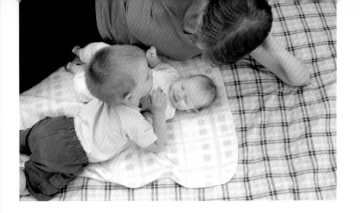

Slice of Life

We took a quick look at slice-of-life portraits earlier (see page 10). This is when your subjects know they are being photographed, but the picture-taking becomes fun because it isn't a "line up against the wall and smile" situation.

Instead, you're making photography fun by taking pictures of daily life. If you do it often enough, your family and friends will start to consider it normal. Potty training for kids, homework for adolescents, and a trip to the library or store are all great portraiture opportunities for the creative photographer. These bits of daily life may well be the portraits you'll end up cherishing the most in the years to come.

Today's digital cameras are smaller and lighter than their predecessors. Get in the habit of carrying your camera with you on a daily basis and you'll be amazed at the incredible portraits you can take of every day moments.

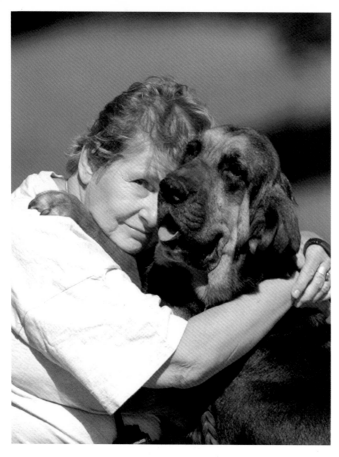

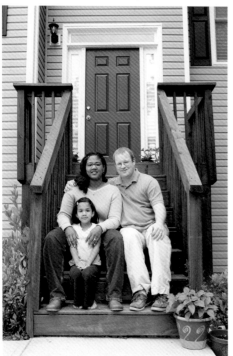

"Go sit on your steps", can lead to a natural looking pose for a small family.

Coach a Pose

The next step is to start coaching your subjects into a pose. You can offer simple instructions that usually work quite well, such as, "Hold your phone but look up at me," or, "Give your dog a hug and look this way." You don't have to manage every detail of the pose, just see what happens when you offer a general direction to your subject.

Get your camera ready as you watch your subjects while they are busy with normal activity, then interrupt them by calling their names. Press the shutter release the moment they look up at you.

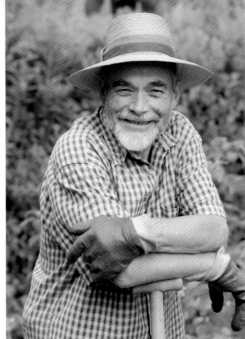
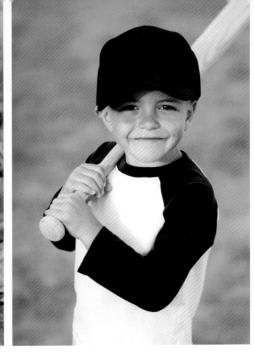

You can also try coaching in a more unobtrusive manner. My favorite semi-candid method is to simply call out to your subject so they look up from their activity and at you for a moment. And if you're ready, a moment is all you need to capture it in a picture. But be prepared—that first unguarded moment is usually the best. This is an excellent technique for shy or uncooperative models.

The images of the little girl walking hand-in-hand with her parents (right) demonstrate a great comparison between a totally posed image and a momentary "Hey you" glance backward. The difference is subtle, but significant. The upper picture looks posed. The lower looks more natural and spontaneous. It makes us feel like we are sharing a joyful secret with this little girl, who is telling us how happy she is to be out for a walk with her parents—and we start to ponder where they may be going.

Getting back to becoming more interactive, you can coach with a dare: "Hey, try this!" Or, for example, the request: "Show me what you have in your hand." Of course you can always act like the director of a movie and tell your subjects to do something fun, like climb a tree, run across a field, or jump on the bed.

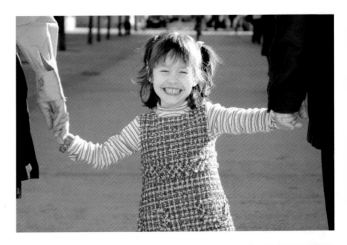

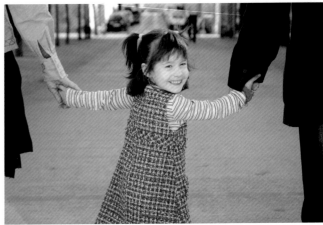

The upper image is fine, but looks posed. Compare that to the glance backward, which appears to have more personality because it looks much more spontaneous.

One active way to shoot a portrait is to direct your subjects to hold hands and run toward you.

Peek-a-Boo!

Every child has played the game of peek-a-boo, so instigating this game photographically is a great tool when shooting younger children. If shooting in a park, I like to hide behind one tree and start the game. Just be sure to have your camera ready for when it starts. It's almost impossible not to get a cute picture of a child when playing this game!

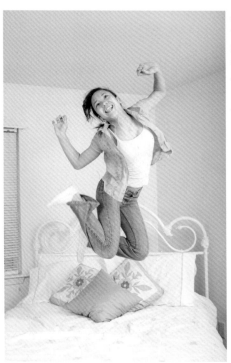

Encourage your models into an activity. "Give your Mom a big, fat kiss," was a great prompt to take this picture of interaction between the son and his mother.

After years of telling your kids not to jump on the bed, asking your teen to do it is bound to yield a fun result!

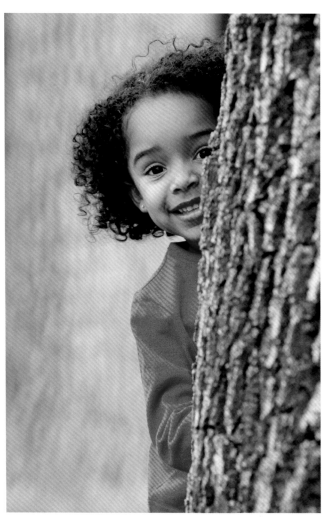

Peek-a-boo is one of the first games that most of us learn. I like to use it to make a photo session more fun for young (and even older) children.

Funny Faces and Pouts

If you enjoy photographing young ones, remember to keep photography fun. Don't make it a chore. Almost every photo session I have with a young model, I ask for at least one funny face. Even if you don't really want that shot, do it! It lightens the mood. It makes it fun. Check out pages 88-89 for fun poses that most kids will love to try.

The other side of the funny faces pose is the moody picture (below). Pouting and moments of the blues are just as much a part of your child's personality as silliness.

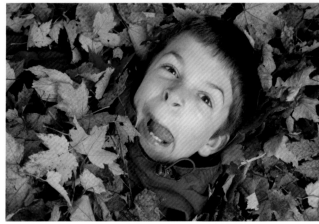

Be sure to ask for a funny face at the start or finish of every photo session. It helps keep photography fun for the kids, and works with adults, as well.

Add Some Props

Adding props can give a sense of scale to a picture, or it can create a mood, tell a story, or just add a dash of color. When you want a more candid style, props help relax your subject by giving them something to do.

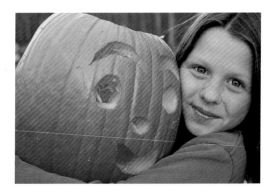

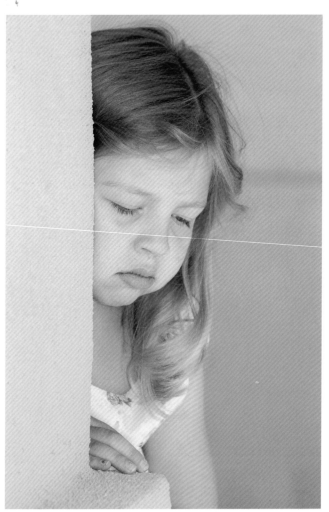

Not every picture has to show a smiling face.

A giant pumpkin dwarfs this young gardener (above). And the chair (below) gives a sense of scale by showing how small this little girl is.

A favorite toy or stuffed animal can help relax a young model and give an insight into the child's interests.

It can be as simple as asking your son or daughter to pretend to sleep beneath the Christmas tree. Or it can get more complex, like whipping up a frothy bubble bath and then painting a bubble beard on your two goofballs.

Don't worry! Setting up a shot like this is not cheating—it's theater. And it is a great way to shoot holiday cards or special themes. Online photofinishers like www.kodakgallery.com will turn your digital pictures into greeting cards with headlines and messages that you can send to friends and family.

My uncle loves botany and is always playing Sherlock Holmes when he finds an interesting tree or flower. So we had some fun with his magnifying glass.

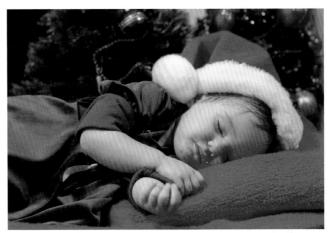

It's not hard to come up with adorable themes for holiday card. Here, the model was asked to pretend he was sleeping.

Complete Setups

Most folks have a little "ham" in them and like to role-play, especially kids—so they're often willing subjects for completely staged "candids." By that I mean photographs that are supposed to look like a part of daily life, but are really staged and choreographed.

The photographer carefully placed the foam where it looked best for a silly bearded bath shot.

Shake It Up!

Traditional portraiture poses are great, and an important part of any photo album. But don't get hung up on static poses—have a little fun! Here are a number of different approaches to consider.

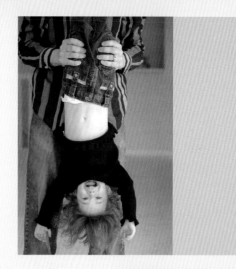

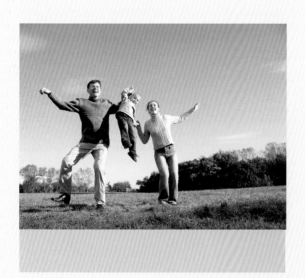

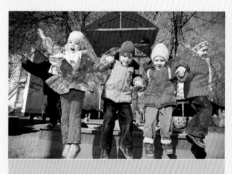

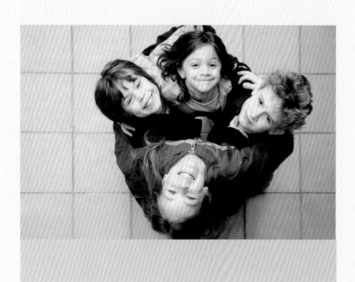

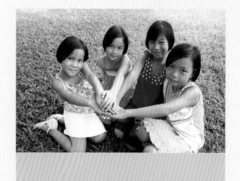

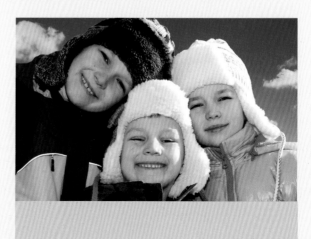

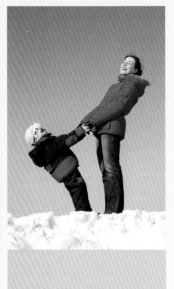

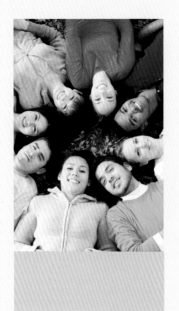

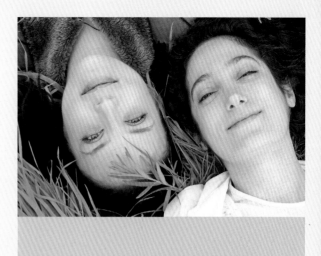

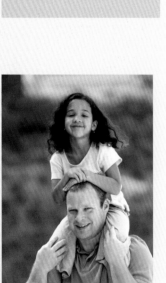

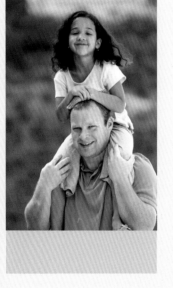

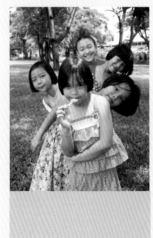

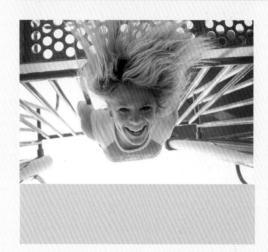

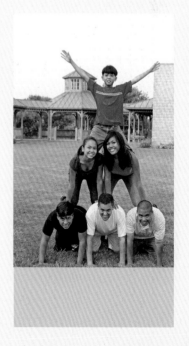

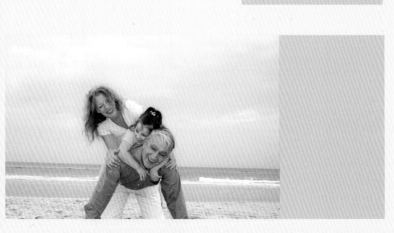

Tips for Babies & Toddlers

Get to Their Level

In Chapter 3, we investigated the eye-level rule. Use it on babies too! Match their true eye level with your camera height for the most intimate portraits. Since babies are smaller than adults, you will want to raise them somehow if you don't want to lie on the floor to get to eye-level. The over-the-shoulder shot is a tried-and-true favorite.

Break the Eye-Level Rule!

Sometimes a high angle on a baby is successful for portraiture. Looking down emphasizes their small size and vulnerability. Cribs are ideal for this.

Backgrounds for Babies

Pale colors go along with soft lighting for a true nursery feeling. Try to get a simple background like a blanket or sheet (left). Avoid really busy backgrounds (right) that compete with the baby for the viewer's attention.

Extra Soft Lighting

Babies often look best in the softest possible light, such as light from a north-facing window. It always gives the feeling of a nursery, and the bright mood of morning.

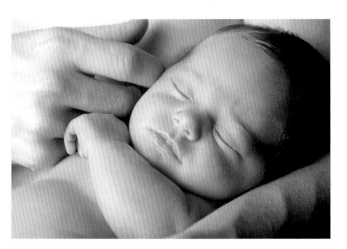

Fascination with the World

As your baby starts to grow up, don't forget those slice-of-life pictures we've talked about. Photographs of your child exploring and learning will become treasured portraits.

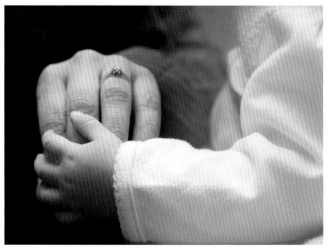

Size Comparisons

How small is your baby? Include a parent's hand in the picture for comparison. You may want to make this an annual event and try to replicate the picture as your child (and his or her hands) grows.

Use Exposure Compensation

Your pictures may lose detail or look bluish when shooting a baby on white. This is because the camera is under-exposing the image. Use plus exposure compensation if your camera has this capability. Blue casts can also be caused by improper white balance (see page 24).

Posing

7

I n earlier chapters we examined some different portrait styles and shooting technqiues. Now it's time to look at the nuances in posing that will help you create exceptional portraits.

Body Position

If off-centered compositions tend to yield more interesting pictures, it shouldn't be a surprise that angled body poses can also improve portraits. Nobody ever likes his or her driver's license picture, and that is partly because the pose (squared off and staring at the camera) is rarely the most complimentary.

It is often best to turn the torso at an angle to the camera, even if the subject's head is pointed at you. The portrait below of a nationally ranked inline speed skater is a good example. Her shoulders are positioned at an angle of about 45 degrees to the camera. Usually I coach this by asking the model to slowly start stepping in a partial circle. Once she has turned as far as I want, I say, "Now look back at me without moving your shoulders."

I asked this model to turn her body so that her left shoulder was farther from the camera. Then I asked her to turn her head so that she was looking at the camera.

Straight-on shots are rarely as flattering as those where the body is slightly turned at an angle to the camera. Talk to your subjects to coach them a different position if you find they are facing you directly.

We discussed earlier how a person's placement in the frame could make a big difference in the feeling of the picture. That compositional technique bears revisiting. Compare the examples to the right. You will see what a different feeling these two portraits create. Certainly the different expressions have an impact. But so does the direction of their heads. Note how the boy's head is tilted to the center of the frame and he is making eye contact, while the girl's head is turned toward the edge of the frame and she is looking away from the camera, out of the frame. This gives a disconcerting, unstable feeling to the composition, and evokes concern for the girl.

The expressions of the young models make a big difference in the mood of these portraits, but so do their head positions and the directions of their eyes. The boy's photo, with eye contact and head tilted toward the middle of the picture, gives a more stable emotional feeling.

Hands

Hands are tough to pose naturally. Most subjects become very self-conscious of their hands when you start to take their portrait. They just don't seem to know what to do with them! It is often a good idea to coach them into an attractive hand position.

If their hands are well manicured and look good, you can often work them into a pose, perhaps placing them under your subject's chin to frame their face. Just remember to think of the hands as a graphic element, and ask yourself if they add to the picture or distract from it. Especially with women, a side view of the hand generally makes it look more elegant and the fingers more elongated, whereas showing the palms or back of the hands is less graceful. Even the most delicate hands can look big and bulky when their broadest side is photographed.

Delicacy is not as important in male portraits, so it makes less of a difference whether you show the side or front of the hand. In general, showing the hand in profile (from the side) is usually the most desirable. It might feel unnatural for a person to hold their hand that way, but you can make it look both natural and graceful if you coach the exact position, like having the model frame their chin with their fingers.

If you want to alter a person's posture, you can ask them to put their hand on their hip or tuck the fingers of one hand into their pocket. This will often cause them to shift their hips and look more comfortable.

Hands under the chin can add interesting graphic lines to a portrait.

The broad back of the hand (upper photo) is less dainty than the side view of the fingers.

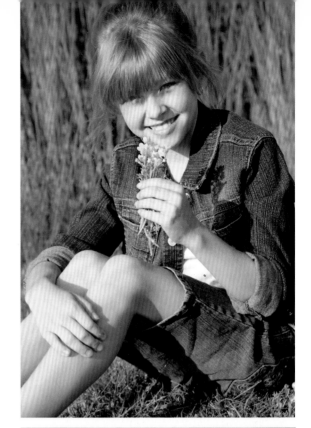

Painted flowers on the face can serve as a prop, adding color and personality to a portrait.

Posing with Props

As well as considering what to do with hands, think about the possible benefits of using props. Sometimes it is wonderful to add a small prop to the photo—a freshly picked flower, a favorite toy, or a seasonal trinket. Take care in positioning the prop, so that it enhances the picture rather than robbing all the attention for itself. In the photos of the girl with yellow flowers to the right, the placement of the flowers is compositionally important. In the top example, the yellow flowers held below her chin are a distraction. Our eye goes right to them instead of to her eyes. In the lower picture, they are being held higher but to the side. Our eyes go to them first, but then they lead to the model's eyes. As such, this becomes the more successful picture.

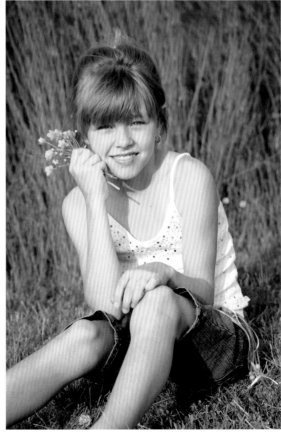

Holding the flowers in front of the subject's face detracts from the picture, while moving the flowers to the side of her face enhances it.

Photographing Pairs

Groups of two are a challange to the photographer. Often people stand next to each other, shoulder to shoulder, frequently not touching. Also, after years of being told to "get closer" for pictures, they lean in toward each other and crane their necks to get their heads closer together. Neither is particularly attractive.

For successful portraits of more than one person, it is important that the subjects are visually unified as a pair or group—but this needs to appear natural. Notice how disconnected the man and woman look in the photo to the right above. This disunity is caused by three factors:

1. They are separated by space (there is a big gap between their heads).

2. They are not looking at each other.

3. Their bodies are turned away from each other.

Friends and family members can be encouraged to put their arms around each other and their cheeks together for a portrait that communicates their bond. Try to overlap their bodies a bit to avoid having them lean toward each other, which can look awkward. Instead, put their bodies sideways as in the portrait of the two girls (right middle), or have one person positioned with their body slightly in front of the other so they visually overlap at the shoulders. Be sure the shorter person is the one in front!

Other types of physical contact are a great way of creating a harmonious portrait of two people. Coach your subjects to rub foreheads or noses, or give a big noisy kiss on the check. All may elicit wonderful expressions!

This pose does not communicate togetherness because their bodies are turned away from each other.

A big hug among friends is a great way to get kids close without making the subjects look stiff or overly posed.

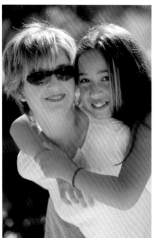

A piggyback ride can bring the heads of a parent and child closer together.

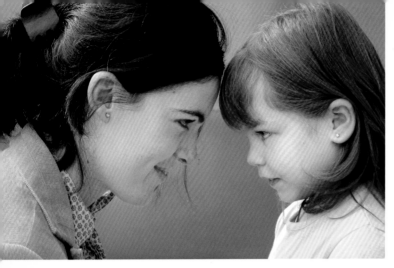

Telling your subjects to touch their faces together can break any tension and yield wonderful, happy expressions for portraits. It even works for animal portraits!

Eye Contact

We have already stressed the importance of your subjects' eyes in portrait photography, and the advantages of shooting at eye level. But what about the direction of the eyes, especially when there are two people (or more) in the portrait? Eye contact can change the feeling of the picture in several ways. The chart to the right describes some of the more common pictures that result from the direction of your subjects' eyes.

The Direction of the Eyes

Eyes at Camera	If the subjects are looking at the camera, the viewer feels related to the people. This is the classic portraiture technique. Ask your subjects to look at the lens.
Eyes at Each Other	This is a great way to communicate the connection between two individuals. The subtext or story of this portrait is the bond they share.
Eyes at One Person	If one or more people are looking at a single individual, the story is about the person being observed, and the love and respect the others have for him or her.
Looking Away in Same Direction	This creates a moodier portrait that is still unified because your subjects are gazing at something with shared interest.
Looking Away in Different Directions	Discord is created by this composition, and it is rarely perceived as a loving pose. Turning bodies away from each other will enhance the discord.

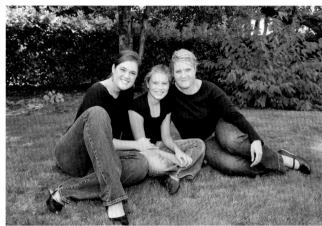

Looking directly into the lens connects the subjects with the viewers.

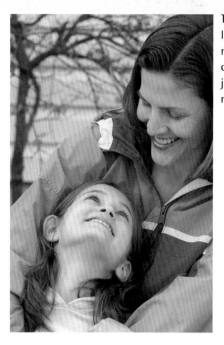

This is an even stronger link than the photo in the middle of the left-hand column because the subjects are hugging and making eye contact.

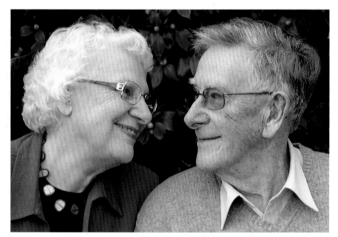

Even though there is a gap between their heads, this couple is unified by the look they share with eyes on each other.

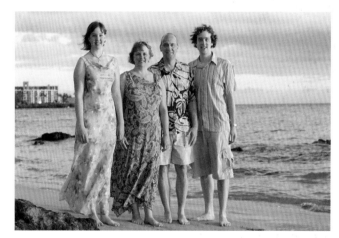

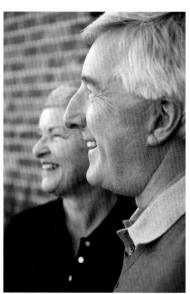

They may not be looking at the camera, but we feel a sense of unity because they are looking in the same direction (a shared experience). This feeling is enhanced because their bodies overlap and the woman's torso is turned toward the man.

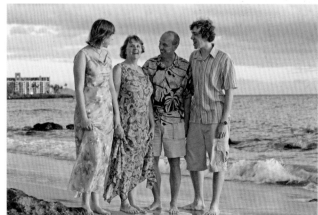

Both photos above are nice family portraits, but the story each tells is different. When the father and children turn toward the mother (bottom), the picture becomes about her. Perhaps it is her birthday or Mother's Day.

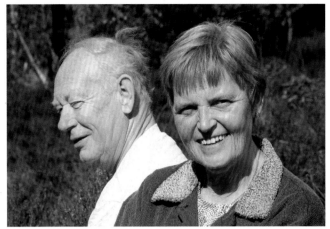

This portrait looks disjointed because the man is looking away from the woman and the camera. His body is also turned away from her.

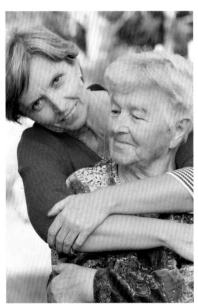

The picture at left is really a portrait of the daughter in which the mother happens to be present, because the younger woman looks at the camera while her mother looks away. The image below becomes a portrait of both because they are looking at each other.

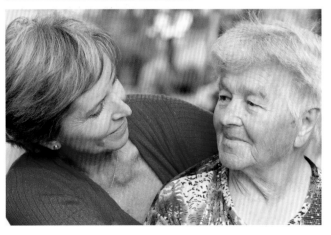

Uneven Heights

People of uneven heights can cause a posing problem. If you want to equalize differing heights for a more face-filling shot, consider seating them. When including children with adults, a lap works great—as does a piggyback ride.

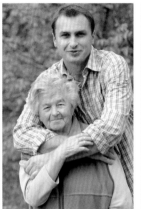

When this grandmother and grandson are standing next to each other, their height difference is much greater than when they are sitting.

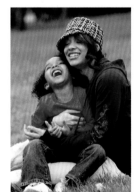

The size difference between young children and their parents can be bridged by a whole host of fun and creative poses.

Alternately, you can emphasize the height differences, such as the portrait of three siblings of different ages (right).

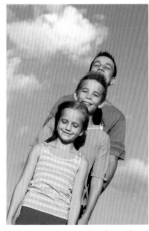

A low angle emphasizes the height differences between a big brother and his siblings.

Groups

When you start adding more than two people to the portrait, body position becomes even more critical. Putting everyone in a lineup, shoulder-to-shoulder, is bad because this creates a picture with a number of gaps. It also makes everyone's heads relatively small, with too much empty space above and below the people.

There are two ways to avoid this that will make a huge impact in your group pictures:

1. Ask the outermost people to turn slightly toward the center. This will emphasize the cohesiveness of the group. If they are sitting in chairs, have them swing their legs in toward the middle of the picture. If they are on the ground, have their knees, torso, or shoulders angled in a bit.

2. Position the people so they are stacked or layered in a tight group. If, for example, you position a group on stairs or a picnic bench at three different vertical levels, the people in the picture will be relatively bigger than if they were lined horizontally across the picture because there will be less wasted space. It's quite amazing how much larger you can get each face when you take the time to position everyone carefully.

Generations of photographers have successfully used the layering or stacking method for good group poses.

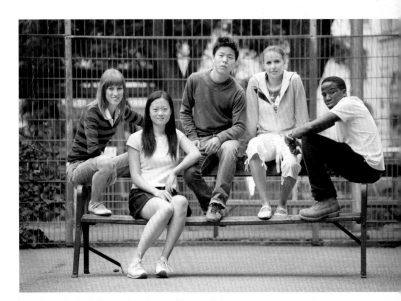

Varying the height and body positions of these teenagers makes a more dynamic picture than a typical lineup. Note how the legs of the outside people are turned inward.

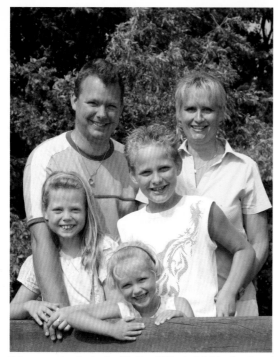

This group is stacked with the littlest child in front and the rest arranged by size or age. This creates several vertical levels of faces, resulting in a tight group that is visually pleasing and has a unified feel.

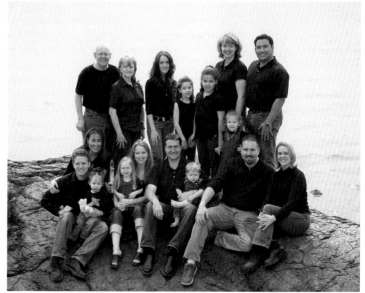

Think of this composition as building a tower. Positioning this family of 17 people into stacked rows helps bring them together in a large but tight group. The matching outfits add to the family feel.

My strategy is to orchestrate the pose. First I try to scout a location that gives me the potential of several heights. As mentioned, stair cases work well. A short stone wall works too. Some of your party can sit on the wall, while others stand behind it. For a really large group, I might put the kids standing in front, then a row of standing adults, then the teens standing or kneeling on the wall behind.

Next I set up my tripod. This makes it easier to have my hands free so I can point and gesture like an orchestra conductor. Plus, if I plan on being in the picture, I'll be ready with the self-timer.

Next I start placing the people one by one. I start with the anchors—individuals old enough to sit quietly for the longest time. Then I start adding people around them. The last row (usually the front) is the kids and pets. And if I plan on being in the picture, I save a space on one of the edges that I can run into.

You can literally stack your subjects to make a human pyramid (left), or the pyramid can be visual (below).

When photographing groups, I take a lot of shots. The more people, the greater the likelihood that someone is going to have a bad expression. It is best to warn everyone that you plan to take 5, 10, or even 20 pictures of the group, so they don't break up the pose after one or two shots.

Don't forget to apply the techniques that you've learned in other chapters to group photography as well. Try moving far away with the telephoto lens setting. Or pick an unusually high or low angle for a fresh take on the family portrait.

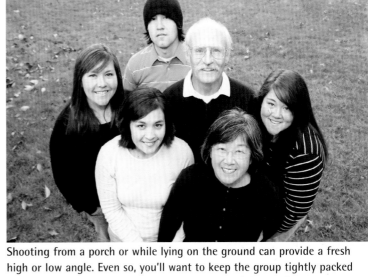

Shooting from a porch or while lying on the ground can provide a fresh high or low angle. Even so, you'll want to keep the group tightly packed and pick a composition that varies the heights of the heads.

You don't need to use a super wide-angle lens if you can move away from your subjects. Here the photographer stood on the bank of the river while the group was posed on the bridge.

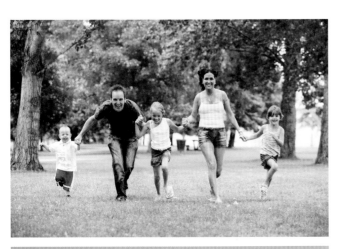

If you must do a lineup, have some fun with it. Ask your subjects to "charge" you, jump for joy, or skip away. It can create lively and memorable portraits.

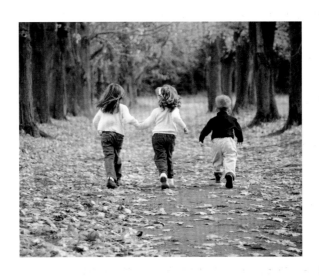

Portraits with Pets

Get Down to Their Level

Even big dogs are smaller than the standing height of most people. Have your model get down to the animal's eye level in order to make pictures without the gap created by such a height discrepancy.

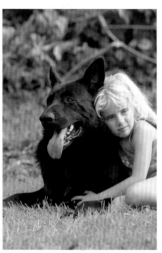 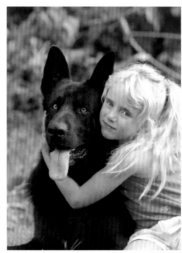

Close the Gaps

Use positive training to help your human and animal subjects interact. Use the animal's sense of smell and love of treats to achieve your goals. An apple in the pocket brings a horse nearby. And peanut butter on a boy's check is a sure-fire way to elicit a doggy kiss.

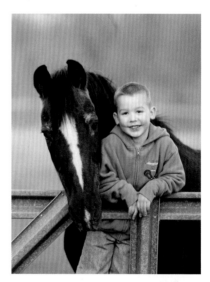

Raise Them Up

Encourage your subject to hold smaller pets. Be careful! Never allow anyone to bring a potentially dangerous pet up close to their face. Even a cute small dog can hurt someone!

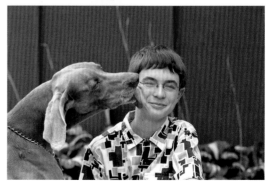

Short Sessions

Most pets have very short attention spans. Several short photo sessions will yield better results than one long one. Always end the photo session if the animal gets stressed.

Lots of Pets!

All I can say is, "Patience, patience, patience!" The more pets you put in one picture, the harder it is to get a picture where everyone looks great. Keep trying, and refer to the Short Sessions tip above.

Animal Behavior

The most successful pet photographers are experts in animal behavior. Instead of trying to force an animal into a certain pose, they use their understanding of behavior to coax it. For example, a heating pad under a photogenic cloth will attract reptiles, as well as other animals in colder weather. And if you substitute tuna fish broth for peanut butter from the tip on the opposite page to get a doggy kiss, you may get an adorable shot of a sniffing kitten.

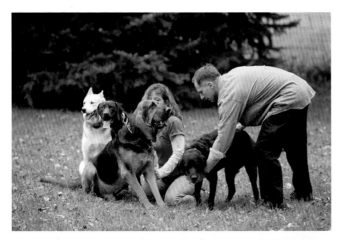

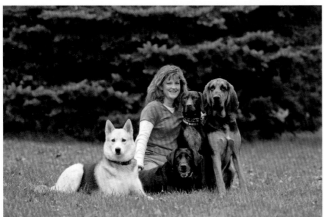

Pets Alone

If you're interested in taking portraits of pets alone, you may be surprised to learn that most of the tips and techniques in this book are applicable to animals.

D-SLR Camera Tips

I f you own a D-SLR camera, you'll have some advantages over other photographers. For starters, it can accept a wide range of professional accessories from flash units (see Chapter 5) to specialized lenses. It also has advanced capabilities that not only improve the quality of your pictures, but also give you creative control of exposure, focus, and white balance. This will allow you to artistically alter the way the picture is rendered.

Lenses

Throughout this book I have talked about zooming from wide to telephoto focal settings for specialized artistic effects. If you own a D-SLR, your camera will accept a broad range of accessory lenses with different advantages and capabilities.

Fast lenses with large maximum apertures of f/2 or f/2.8 allow you to shoot in dim light. Super wide-angle lenses give you the option of shooting large groups in shallow spaces, show a lot of the background, or add creative per-

spective exaggerations to your pictures. And when using super-telephoto lenses, you can shoot frame-filling portraits from a distance. This is great for candids, and often renders the person's features attractively.

All-in-one zoom lenses cover everything from wide to telephoto in one handy package, so you don't need to carry extra lenses. Macro or close-up lenses allow you to focus at closer than normal distances, such as shooting a portrait that just includes a partial face. Specialty lenses can add soft-focus effects. And the Lensbaby® series of lens modifiers can add interesting blur effects.

A moderate telephoto focal length (70mm) is good for shooting facial portraits.

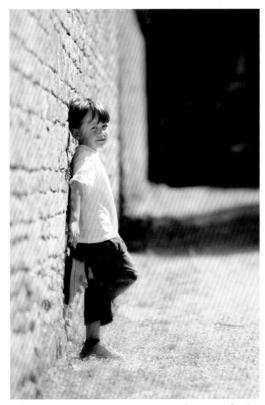

Wide apertures on a telephoto lens (such as f/2.8) will put the foreground and background out of focus. This can help to visually isolate your subject.

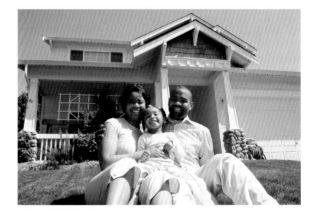

A wide-angle lens allows you to show a broad expanse of background, such as this family's house. This often places your subject in some type of context. Or it can be used to create comical distortions if you move in close to your subjects.

Specialized Gear

In addition to lenses, D-SLR cameras can accept a vast array of specialized gear, including filters, flash units, remote controls, and even underwater housings.

Entire books have been written on filters, but for most portrait photographers I recommend two types:

1. A UV filter will protect your lens from accidental bumps and scratches.

2. A polarizing filter will help reduce reflections on eye glasses and background elements, such as tree leaves and water. And in many situations it will darken the sky in comparison to the clouds.

Be sure to purchase a circular polarizer, as opposed to a linear polarizer, as the later will not work with your camera's autofocusing and autoexposure systems. Likewise, make sure you select a filter designed for digital photography. These filters will have properties that allow them to work better with your digital camera's imaging sensor and anti-aliasing filter.

Underwater camera housings let you shoot pictures in and under the water.

Manual Focusing

Most D-SLR cameras have advanced autofocusing that can identify movement and track your subject, even at high speeds. Multiple autofocusing sensors also help to focus off-centered subjects. In really tricky situations, such as the little girl peering through an abacus (right), you can switch to manual focus. This way, you determine where the camera will focus, rather than relying on the autofocus system that might focus on something other than your desired subject (in this case, the camera might have focused on the abacus beads, leaving the girl's face out of focus).

This set up would trick the autofocusing of most cameras. However, with a D-SLR, the photographer can manually focus on the girl's face for pinpoint accuracy.

Controlling Exposure

Getting the perfect exposure is an advanced topic. But the basic concept is simple: Exposures are made when the camera allows light to enter the lens and record on the digital imaging sensor. A certain amount of light is needed to make the proper exposure in any given situation for a certain subject.

How the camera gets just the "right" amount of light is one of the creative aspects of advanced photography. The amount of light can be controlled in three basic ways:

1. Aperture: This is the size of the opening in the lens. The aperture only allows a certain amount of light to strike the sensor. It also affects how much of the scene (from foreground to background) is in sharp focus.

2. Shutter speed: This is the length of time the shutter is open. Shutter speed not only allows light to strike the sensor for a certain length of time, it also affects how sharp or blurry the picture is due to camera shake, subject movement, or both.

3. ISO setting: This adjusts the camera's response to light. At higher ISO settings, the sensor's output is amplified to simulate film ISO settings. However, higher ISOs also increase noise and other image artifacts.

See page 23 for more about ISO settings. A full explanation about the nuances of aperture and shutter speed selection is more than this chapter can offer. But it is important to understand some basic concepts about exposure, so let's take a quick look.

Aperture Priority Mode (A or Av)

If the depth of field (how much of the scene is in acceptably sharp focus from foreground to background) is most important for your photo, select your preferred aperture using this exposure mode on your camera. When you pick your preferred aperture in A mode, the camera automatically chooses the appropriate shutter speed for proper exposure. If you want to emphasize your subject by placing the background out of focus, select a large f/stop (small f/number) such as f/2.8 (if possible) or f/4. Select a small f/stop (high f/number), like f/11 or f/16, to get more of your scene in sharp focus.

A wide aperture causes foreground elements to go out of focus and here makes a soft frame around the baby's face (see page 54 for more on framing).

If the people in the background were in focus, they would make it harder to see the young violinist. An aperture of f/4 puts them out of focus with a telephoto lens and improves the capability of the camera to record this indoor scene without flash.

By using an aperture of f/3.5 to put the Dad out of focus, the story of this picture becomes the girl.

These photos were take at three different apertures: f/2.8 (top), f/8 (middle), and f/32 (bottom). Notice how the background changes from blurry with the aperture wide open to much sharper and more distracting with a very small aperture.

Shutter Priority Mode (S or Tv)

In Shutter Priority mode, instead of picking the aperture, the photographer selects his or her preferred shutter speed, and the camera chooses the aperture for the proper exposure.

If you are shooting a moving subject and the amount of blur (or absence of blur) is most important, select your preferred shutter speed using this exposure mode. A shutter speed of 1/500 is faster than 1/50, so it has better action-stopping capability.

Panning at Slow Shutter Speeds

Panning your camera can help you get better pictures of moving subjects, even at slower shutter speeds. To pan the action, track the subject in the viewfinder before, during, and after you push the shutter button. If you do it smoothly and at the right speed, the subject will look relatively sharp and the background will be a smooth blur.

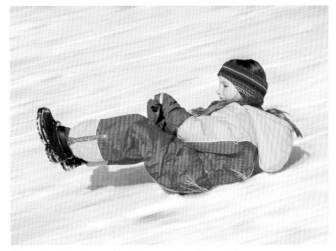

Use a fast shutter speed for most action pictures. However, if you want to create an artistic blur like this, do the opposite! Select a slow shutter speed and pan the camera to match the speed of the subject.

Similarly, running water and rain can be turned into an attractive blur (rather than droplets) with a longer shutter speed.

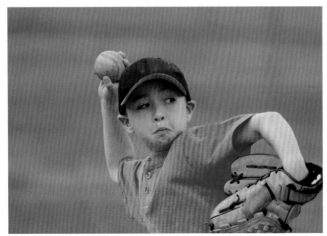

A fast shutter speed is needed to freeze the motion for tack-sharp action pictures.

Exposure Compensation

No camera is perfect, and occasionally yours may get fooled by a tricky lighting situation, or an especially light or dark subject. Most D-SLR cameras, and a few point-and-shoot cameras, have an exposure compensation option, which is usually indicated by a +/- EV symbol.

In a backlit situation, overexposing the image (plus exposure compensation) will brighten a subject that might normally be too dark, but it will also make the background much lighter.

Pictures that have a lot of white in them can sometimes fool a camera into underexposing. You can improve your exposure, as done here, by using plus exposure compensation and reshooting.

If your picture looks too light or too dark when you review it on your camera's monitor, you may want to reshoot it using exposure compensation. If your scene looks too bright and washed out, you need to "subtract" light, so use minus exposure compensation. If your scene looks too dark, you need to "add" light, so use plus exposure compensation. Note that underexposed images sometimes pick up a blue cast.

It can be difficult to properly expose pictures that have a lot of dark tones in them because the camera may overexpose the picture. If this happens, your picture will look murky or bluish. Review pictures on your LCD monitor and use minus exposure compensation, as done with this photo.

Manual Exposure Mode (M)

With a D-SLR you can also switch to Manual Exposure mode. In this case, you select both the aperture and the shutter speed. To use M mode effectively, it helps if you have a basic understanding of exposure. If not, you can easily under or overexpose the subject and ruin your pictures. However, making mistakes in Manual mode is sometimes a good way to actually learn the basic relationships between aperture, shutter speed, and ISO, as long as you try to figure out why an exposure did not work. With digital, it is a simple matter to experiment and delete those image files that result in poor exposure. Most D-SLR cameras will show a display in the edge of the viewfinder that indicates whether the camera thinks the exposure you have set is too much or too little.

If you want to keep a silhouette black, you may have to use minus exposure compensation, depending on the situation. And don't forget to turn off your flash.

Image-Processing Software

9

Digital photography opens up a whole new field of art once you bring your pictures onto your computer. Using image-processing software like Photoshop or Photoshop ® Elements, you can correct and enhance your pictures, or make entirely new artistic creations. The choices are limited only by the cost and availability of the software programs, and the time needed to learn and apply these tools.

This chapter describes a few techniques that I use most often in portrait photography. You will find an introduction to the processes that can definitely help improve your portraits. Refer to the software program's instruction manual or Help menu for details on how to accomplish each task. But remember, if you try any of them, be sure to give a new and different name to the modified image file before saving it, or the original picture information will be forever lost.

Cropping Your Pictures

After you take a picture and are reviewing it on your computer, think about cropping. Ask yourself: "Is there extra area in this picture that I don't need? Is there anything distracting that I should eliminate?"

If the answer is "Yes" to either of these questions, crop the picture. Remember, you can crop a horizontal picture into a vertical, and vice versa. You can even take it to

extremes: The boy in the photos to the right was cropped to just show part of his face. The result is very cute and a little bit out of the ordinary.

Cropping in the computer after you take the picture lowers the overall resolution. This is because, unneeded as they may be, the pixels you crop are part of the original photo. So you are actually throwing away part of the picture—literally cutting out a number of pixels that made up the photo's native resolution. That's why it is always a good idea to shoot at your camera's highest resolution setting. The more pixels you have (higher resolution) to begin with, the more you can afford to crop and still have enough remaining to make a nice print.

You can also use cropping to change one good picture into another, different—yet still great—picture.

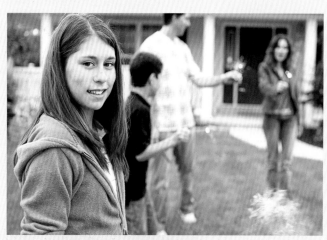

A primary use of digital cropping is to remove distracting elements from a photo's background.

Automatic Repairs

Most photo software programs offer an automated, overall repair option that helps "fix" improper exposure or other errors. This will automatically correct the color, contrast, brightness, and other aspects of your digital photograph. For example, snow scenes are often underexposed because the camera's metering system is fooled by the whiteness of the scene. And to compound matters, on overcast days the scene may also have a bluish color because of the shift in the color of the light. As a result of these two issues, many snowy-day portraits may look very blue. The auto repair control will usually remove this cast for you. If the program has a preview option, you will be able to see the suggested changes before committing to them.

However, be careful when applying such automated processing controls. They don't always improve the image, and often take "the fix" too far by overcompensating. So, more often than not, you'll have the best results if you take the time to learn how use the individual software tools to make each enhancement manually.

Brightness/Contrast

You can make a quick improvement to dull-looking pictures by adjusting the brightness and contrast. The Brightness control changes how dark or light the overall picture looks. Contrast adjusts the ratio between shadows, midtones, and highlights.

These controls can be used to add "snap" to images taken in dull or low-contrast lighting. However, you can take it even further and create artistic images by altering them to extremes, as was done with the little boy to the right above.

You can take brightness and contrast to extremes. Used with other software tools, such as selective Masking, the Brightness and Contrast controls make it possible to create an artistic rendition of this boy's portrait.

Dodge and Burn

The overall Brightness control in most programs affects the entire image. However, there will be times that you want to lighten or darken only particular parts of the picture. For example, you can use the Dodge control to lighten one part of the image (often the face) and the Burn control to darken another part of the image (often a background object to make it darker and less distracting).

The Dodge tool can be used to selectively lighten a portion of the photo—in this case, the model's face.

For the best results, adjust the size and strength (or opacity) of the Dodge or Burn tool. It is better to take several light strokes than one strong stroke: This method might take more time to create the lightened or darkened effect, but the result will be smoother and more natural looking.

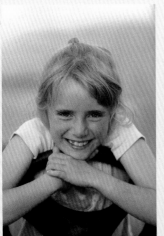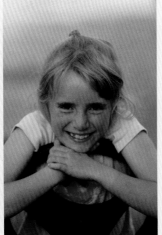

Changes in overall brightness and contrast can improve the look of your digital photograph.

Retouching Improvements

Retouching can be a simple task or very advanced depending on the controls you use and your artistic ambition. In its simplest form, retouching can quickly clean unnecessary or distracting elements from a background. Or it can improve a portrait by removing skin blemishes or lightening the look of wrinkles—or even completely removing them!

The Clone or Stamp tool is one of the easier tools to use. It acts through a digital process as though you are rubber-stamping the picture by picking up "ink" in a pattern from one portion of the image and stamping it down elsewhere on top of unwanted elements in the picture, thereby covering them up. You can quickly remove a facial blemish in a portrait, clear out trash from behind your subject, or simplify the background. Out-of-focus backgrounds or random textured areas (such as grass or bushes) are often the easiest to work with.

Add Text

Adding text to a picture is easy in most image-processing programs. You can write what you want, and then change the size, shape, color, and placement of the words. Choose your color wisely. It needs to stand out from the picture so it can be read, but avoid psychedelic effects because they can be hard to read. Conflicting colors like blue and yellow or green and pink can be hard on the eyes!

If you don't want to put the text in the picture, some online photofinishing sites like kodakgallery.com enable you to add a border with ready-made slogans ("Season's Greeting", "Thank You", and more) or individually typed captions.

You can add text in different sizes, colors, and designs.

Put on Your Happy Face!
& come to my party on Wednesday, 6:00pm

Red-Eye Correction

Sometimes portraits taken with flash can get that annoying red-eye phenomenon. It is most common with pictures taken in dim lighting with a point-and-shoot camera. The Red-Eye Reduction Flash mode on some cameras will reduce it, but many people find the pre-flash strobe or lamp and the delay it causes to be annoying. Most image-processing programs have a simple one-click red-eye correction function that does a pretty good job of eliminating red-eye and restoring the subject's pupil so it looks natural.

Sharpening—The Most Overused Tool

Some software has a Sharpen tool that can improve the appearance of unsharp pictures, and many inexperienced photographers think it can be a cure-all for out-of-focus images. However, there is only so much this tool can do, and it is best used in moderation. Sharpening your image files in the computer does not come without a cost. It can degrade your picture in some circumstances, or even produce unwanted artifacts in the image. It is always best to use proper photo technique to get sharp images in your camera, rather than depend on doing so afterward in the computer. But if it is too late for that, try this tool with a light touch. Also try increasing the contrast slightly.

Color Correction

It is not uncommon for your photograph to have an unwanted color cast. In chapters 1 and 4, I discussed how different types of light have different colors, and how this can be corrected or avoided using white balance controls on some cameras.

However, you may still get a slight color cast to some pictures. You may not even realize your photo has cast until you see a corrected or improved version. Photoshop and Photoshop Elements software offer a quick way to check by using a command for color variations. First it shows your original, then versions with more red, green, blue, cyan, yellow, and magenta, as well as lighter or darker versions. Click on the one you like best and you're ready to go. Other software has sliding bars you can move to adjust the color.

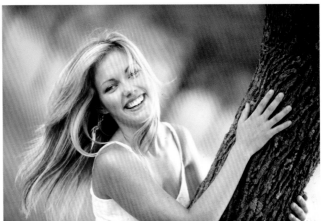

Color casts (top) can quickly be corrected in image-processing software.

Color Modes

Most software programs offer a set of color or picture modes that lets you instantly change the way the picture looks. Most commonly, these include changing a color picture into black and white, sepia, posterized, super-saturated, duotone, and more. Advanced "filters" can even be used to create artistic effects, such as making your photo look like it is a painting or charcoal drawing.

It can be interesting to see what your pictures look like when turned into black and whites. Check your software for a black-and-white or grayscale mode, which sometimes may be called monotone. This will discard all the colors and you'll be left with a traditional black-and-white image.

If you want to make that new black-and-white picture look antique or different in some way, change it back to RGB mode (color). It will still look black and white in your program, but now you can use the color balance or color variation controls to add tones to the pictures. Sepia (brownish) and cyan (bluish) are popular choices.

Add or Fade Color

You can also add color to make a black-and-white image look hand-colored. This can be done traditionally, by printing out the picture and then painting it with special watercolor or oil paints made for photographs. Or, if you're skilled with image-processing software, you can add the colors using layers and opacity settings. Another option is to desaturate the colors. If you do it selectively using layers and masks, you can create an old-time, hand-colored look. The possibilities are almost endless.

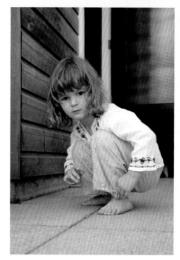
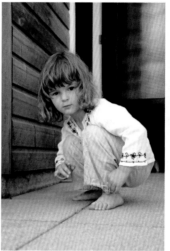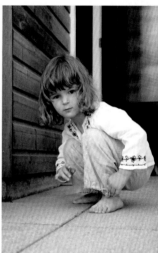

It's easy to change a color picture to black and white in the computer. When most people say, "black and white," they really mean a photo made up of shades of gray (grayscale). And, your black-and-white pictures don't need to be just gray tones! It is easy to add an antique brown, blue, or other color to the image.

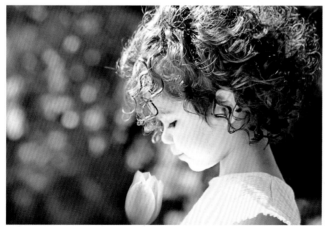

Hand coloring has been done manually on prints for over one hundred years. These same effects can be added with image-processing software.

Selectively desaturating the color in an image can give it a vintage or faded look.

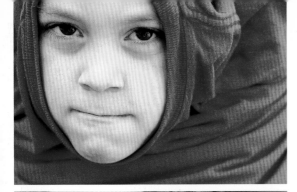

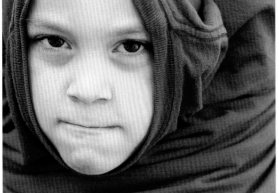

Colors can be completely changed for artistic effect.

Blur or Soft Focus

Advanced image-processing software programs have special filters and controls for soft and blur effects. They can be applied to the entire image, or just the highlights or shadows. In the image of the father and son below, softness was added to the highlights.

Soft effects can be added with filters and other attachments (like the Lensbaby) placed on the camera's lens, or in the computer with software tools long after the picture has been taken.

Collage and Complete Fantasy

If you enjoy artistic pursuits, you may want to take a class that details advanced techniques for specific image-processing programs, such as Photoshop or Elements. Using collaging techniques, digital paintbrushes, and advanced functions like layers, masks, and opacity, you can create some amazing portraits that combine reality with fantasy. Below are a few examples of what can be done.

Several images of a fairy princess were combined for a dreamlike effect.

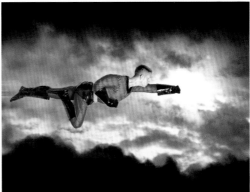

The superhero and sky were photographed separately, and combined together on the computer.

Two photos—the zipper and the boy—were combined into one using image-processing software.

A moth and a woman were combined for a surreal look.

Glossary

acuity
The definition of an edge between two distinct elements in an image that can be measured objectively.

Adobe Photoshop CS
Professional-level image-processing software with extremely powerful filter and color-correction tools.

Adobe Photoshop Elements
An image-processing program that has a comprehensive range of image-manipulation options, though it lacks some of the more sophisticated controls available in Photoshop.

angle of view
The area seen by a lens, usually measured in degrees across the diagonal of the film frame.

aperture
The opening in the lens that allows light to enter the camera. Aperture size is usually described with an f/number. The larger the f/number, the smaller the aperture; and the smaller the f/number, the larger the aperture.

Aperture Priority mode
A type of automatic exposure in which you manually select the aperture and the camera automatically sets the shutter speed.

artifact
Information that is not part of the scene but appears in the image due to technology.

artificial light
Usually refers to any light source that doesn't exist in nature, such as incandescent, fluorescent, and other manufactured lighting.

automatic exposure
When the camera measures light and makes the adjustments necessary to create proper image density on sensitized media.

automatic flash
An electronic flash unit that reads light reflected off a subject (from either a pre-flash or the actual flash exposure), then shuts itself off as soon as ample light has reached the sensitized medium.

available (ambient) light
The amount of illumination at a given location that applies to natural and artificial light sources but not those supplied specifically for photography. It is also called existing light or ambient light.

backlight
Light that projects toward the camera from behind the subject.

bounce light
Light that reflects off of another surface before illuminating the subject.

bracketing
A sequence of pictures taken of the same subject but varying one or more exposure settings, manually or automatically, between each exposure. When provided automatically by the camera, it is called auto exposure bracketing. Some cameras can also bracket white balance.

brightness
A subjective measure of illumination. See also, luminance.

built-in flash
A flash that is permanently attached to the camera body. The built-in flash will pop up and fire in low-light situations when using the camera's automated exposure settings.

card reader
A device that connects to your computer and enables quick and easy download of images from memory card to computer.

chrominance
A component of an image that expresses the color (hue and saturation) information, as opposed to the luminance (lightness) values.

close-up
A general term used to describe an image created by closely focusing on a subject. Often involves the use of special lenses or extension tubes. Also, an automated exposure setting that automatically selects a large aperture (not available with all cameras).

color balance
The average overall color in a reproduced image. How a digital camera interprets the color of light in a scene so that white or neutral gray appear neutral.

color cast
A colored hue over the image often caused by improper lighting or incorrect white balance settings. Can be produced intentionally for creative effect.

color space
A mapped relationship between colors and computer data about the colors. The sRGB color space is employed by most cameras although the K10D can also use the Adobe RGB color space with its wider color gamut (recording range) that is useful when making inkjet prints.

color temperature
A numerically expressed value, usually in degrees Kelvin, to communicate the color of the light illuminating a subject. A high number denotes a bluish (colder) color while a low number denotes a reddish (warmer) color. Many digital cameras include a color temperature adjustment as one of the white balance options.

compression
A method of reducing file size through removal of redundant data, as with the JPEG file format.

contrast
The difference between two or more tones in terms of luminance, density, or darkness.

cropping
The process of extracting a portion of the image area.

dedicated flash
An electronic flash unit that talks with the camera, communicating data such as flash illumination, lens focal length, subject distance, and reflectivity, and sometimes flash status.

depth of field
The image space in front of and behind the plane of focus that appears acceptably sharp in the photograph.

electronic flash
A device with a glass or plastic tube filled with gas that, when electrified, creates an intense flash of light. Also called a strobe in conversational terms.

exposure
When light enters the camera and reacts with the sensitized medium. The term can also refer to the amount of light that strikes the light sensitive medium.

exposure compensation
An in-camera feature that allows for increasing image brightness (with a plus setting) or decreasing image brightness (with a minus setting).

file format
The form in which digital images are stored and recorded, e.g., JPEG, RAW, TIFF, etc.

filter
Usually a piece of plastic or glass used to control how certain wavelengths of light are recorded. A filter absorbs selected wavelengths, preventing them from reaching the light sensitive medium. Also, software available in image-processing computer programs can produce special filter effects.

flare
Unwanted light streaks or rings that appear in the viewfinder, on the recorded image, or both. It is caused by extraneous light entering the camera during shooting. Use of a lens hood can often reduce this undesirable effect.

focal length
When the lens is focused on infinity, it is the distance from the optical center of the lens to the focal plane.

focal plane
The plane on which a lens forms a sharp image. Also, it may be the film plane or sensor plane.

focus
An optimum sharpness or image clarity that occurs when a lens creates a sharp image by converging light rays to specific points at the focal plane. The word also refers to the act of adjusting the lens to achieve optimal image sharpness.

f/stop
The size of the aperture or diaphragm opening of a lens, also referred to as f/number or stop. The term stands for the ratio of the focal length (f) of the lens to the width of its aperture opening. (f/1.4 = wide opening and f/22 = narrow opening.) Each stop up (lower f/number) doubles the amount of light reaching the sensitized medium. Each stop down (higher f/number) halves the amount of light reaching the sensitized medium.

gray scale
A successive series of tones ranging between black and white, which have no color.

guide number (GN)

A number used to quantify the output of a flash unit. It is derived by using this formula: GN = aperture x distance. Guide numbers are expressed for a given ISO in either feet or meters.

histogram

A representation of image tones in a graph format.

hot shoe

An electronically connected flash mount on the camera body. It enables direct connection between the camera and an external flash, and synchronizes the shutter release with the firing of the flash.

image-processing program

Software that allows for image alteration and enhancement.

ISO

A term for industry standards from the International Organization for Standardization. When an ISO number is applied to film, it indicates the relative light sensitivity of the recording medium. Digital sensors use film ISO equivalents, which are based on enhancing the data stream or boosting the signal.

JPEG

Joint Photographic Experts Group. This is a lossy compression file format that works with any computer and photo software. JPEG examines an image for redundant information and then removes it. At low compression/high quality, the loss of data has a negligible effect on the photo. However, JPEG should not be used as a working format in a computer —the file should be reopened and saved in a format such as TIFF, which does not compress the image or uses "lossless" compression.

lens

A piece of optical glass on the front of a camera that has been precisely calibrated to allow focus.

lens hood

Also called a lens shade. This is a short tube that can be attached to the front of a lens to reduce flare. It keeps undesirable light from reaching the front of the lens and also protects the front of the lens.

macro lens

A lens designed for extremely close focusing and high magnification (usually to 1x, also called a 1:1 reproduction ratio) with superior image quality in such applications.

Manual Exposure mode (M)

A camera operating mode that requires the user to determine and set both the aperture and shutter speed. This is the opposite of automatic exposure.

megapixel (MP)

A million pixels.

memory card

A solid state removable storage medium that can store still images, moving images, or sound, as well as related file data. There are several different types, including SD, CompactFlash, and Sony's Memory Stick.

menu

A listing of features, functions, or options displayed on a screen that can be selected and activated by the user.

midtone

The tone that appears as medium brightness, or medium gray tone, in a photographic print.

noise

The digital equivalent of grain. It is often caused by a number of different factors, such as a high ISO setting, heat, sensor design, etc. Though usually undesirable, it may be added for creative effect using an image-processing program. See also, chrominance noise and luminance.

overexposed

When too much light is recorded with the image, causing the photo to be too light in tone.

pan

Moving the camera to follow a moving subject. When a slow shutter speed is used, this creates an image in which the subject appears sharp and the background is blurred.

perspective

The effect of the distance between the camera and image elements upon the perceived size of objects in an image. It is also an expression of this three-dimensional relationship in two dimensions.

pixel

The base component of a digital image. Every individual pixel can have a distinct color and tone.

RAW
An image file format (usually proprietary to a camera manufacturer) that has little or no internal processing applied by the camera. It contains 12-bit color information, a wider range of data than 8-bit formats such as JPEG.

RAW+JPEG
An image file format that records two files per capture; one RAW file and one JPEG file.

resolution
The amount of data available for an image as applied to image size. It is expressed in pixels or megapixels, or sometimes as lines per inch on a monitor or dots per inch on a printed image.

RGB
Red, Green, and Blue. This is the color model most commonly used to display color images on video systems, film recorders, and computer monitors. It displays all visible colors as combinations of red, green, and blue. RGB mode is the most common color mode for viewing and working with digital files onscreen.

saturation
The degree to which a color of fixed tone varies from the neutral, grey tone; low saturation produces pastel shades whereas high saturation gives pure color.

sensitivity
See ISO.

shutter
The apparatus that controls the amount of time during which light is allowed to reach the light sensitive medium.

Shutter Priority mode
An automatic exposure mode in which you manually select the shutter speed and the camera automatically sets an appropriate aperture.

single-lens reflex
See SLR.

SLR
Single-lens reflex. A camera with a mirror that reflects the image entering the lens through a pentaprism or pentamirror onto the viewfinder screen. When you take the picture, the mirror reflexes out of the way (moving into an up position), the focal plane shutter opens, and the image is recorded.

standard lens
Also known as a normal lens, this is a fixed-focal-length lens of approximately 35mm for the K10D. In contrast to wide-angle or telephoto lenses, a standard lens views a realistically proportionate perspective of a scene.

synchronize
Causing a flash unit to fire simultaneously with the complete opening of the camera's shutter.

telephoto lens
A lens with a long focal length that enlarges the subject and produces a narrower angle of view than you would see with your eyes.

TIFF
Tagged Image File Format. This digital format uses no compression and is popular for use in a computer. It will not affect when opened and resaved repeatedly.

tripod
A three-legged stand that stabilizes the camera and eliminates camera shake caused by body movement or vibration. Tripods are usually adjustable for height and angle.

TTL
Through-the-Lens, i.e. TTL metering.

white balance
A control to adjust color temperature to match the color of the light source; ideally, the image should be accurate without a color cast.

vignetting
A reduction in light at the edge of an image due to use of a filter or an inappropriate lens hood for the particular lens.

wide-angle lens
A lens that produces a greater angle or field of view than you would see with your eyes, often causing the image to appear stretched. See also, short lens.

Wi-Fi
Wireless fidelity, a technology that allows for wireless networking between one Wi-Fi compatible product and another.

zoom lens
A lens that can be adjusted to cover a wide range of focal lengths.

Index